OBSERVATIONS

ON THE

R I V E R W Y E,

AND SEVERAL PARTS OF

SOUTH WALES, &c.

RELATIVE CHIEFLY TO

PICTURESQUE BEAUTY:

MADE IN THE SUMMER OF THE YEAR 1770.

By WILLIAM GILPIN, M.A.

PREBENDARY OF SALISBURY,
AND VICAR OF BOLDRE NEAR LYMINGTON

PALLAS ATHENE

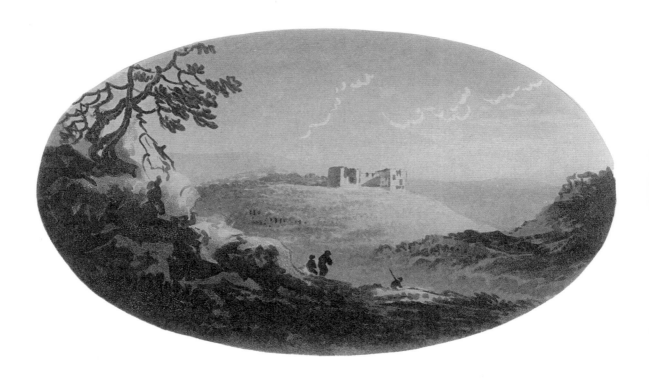

CONTENTS

INTRODUCTION
by Richard Humphreys
page 7

PREFATORY LETTER TO DR. MASON
page 13

OBSERVATIONS ON THE RIVER WYE

CONTENTS

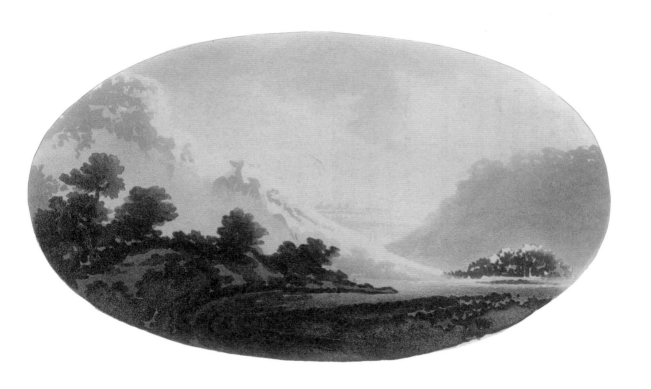

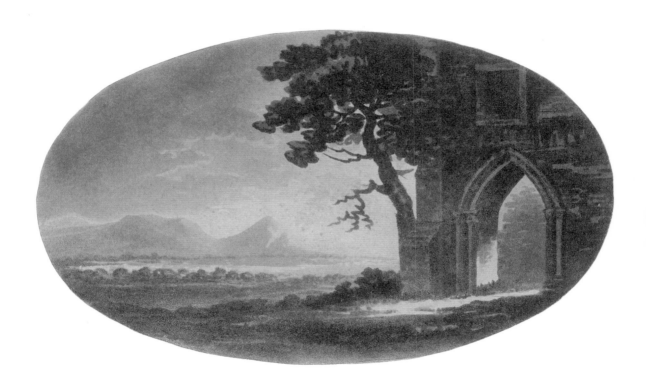

INTRODUCTION

RICHARD HUMPHREYS

William Gilpin was a pioneer in the appreciation of the British landscape. His celebrated series of Tours *of the British regions, published from 1782 onwards, became the main source of inspiration for a generation of travellers in search of 'picturesque' landscape. While his strictures on what to look for and what to avoid were soon the butt of much satire, Gilpin's ideas had a lasting impact on the way we view the landscape. His writings stand as significant highlights in the great succession of English writing on art during the Romantic period, from Edmund Burke and Sir Joshua Reynolds, to William Hazlitt and John Ruskin. Gilpin's development of the concept of the picturesque make a powerful contrast, in particular, to Burke's theories of the sublime, which can be linked to the more grandiose and dark expressions of landscape art during that period. Where Burke seems to produce Turner's most dramatic scenes, the gentler constructions of Gainsborough's rural imagination*

might be seen as visual expressions of Gilpin's more re-assuring ideas.

Gilpin was the son of Captain John Bernard Gilpin, an infantry officer who was eventually garrisoned in the quiet town of Carlisle. There he became a keen painter and etch-er and was the focus of a thriving literary and artistic circle. His art included landscape sketches as well as ambitious history subjects and although only drawings and etchings survive as evidence of his style, his work was certainly high-ly regarded by his son. His teaching of a number of future artists, including his son, emphasised in particular the ideas and techniques of Alexander Cozens. Through his own work Captain Gilpin passed on to his son a preference for, and facility with, pen and grey-wash and tinted drawing.

William Gilpin was born in Carlisle in 1724 and edu-cated at The Queen's College, Oxford. There he continued his drawing, sketched whenever he took walks, learned some

basic etching techniques and became a fledgling connoisseur of Old Master painting. He was ordained in 1748, also the year he published his first essay, a polite sermon even, on the principles of landscape appreciation, A Dialogue upon the Gardens of the Right Honourable the Lord Viscount Cobham at Stow. His readers are encouraged to view Stowe gardens as if they were looking at a composed landscape painting. He endorses a taste for 'natural' over artificial landscape and cites Virgil frequently as an author to be preferred over Homer and as a 'great master in landscape'.

The most significant influence upon Gilpin's ideas is certainly that of Anthony Ashley Cooper, the third Earl of Shaftesbury whose Characteristics (1711) were the most important and innovative expression of æsthetic and moral ideas of their time. As a devout Anglican Gilpin rejected Shaftesbury's controversial deism, but was a follower of his in all moral and æsthetic matters. According to Shaftesbury, the ultimate end of religion, as well of virtue, beauty and philosophical understanding (all of which turn out to be one and the same thing), is to identify completely with the universal system of which one is a part. Shaftesbury presented a hugely influential new ideal of the gentleman whose æsthetic instincts might be developed in harmony with his

morality and sense of god. For Gilpin, the link of such notions to his passion for the natural world and the correct way of appreciating it was inescapable. His Tours were to be a popularisation of a new religion of nature.

During the 1750's Gilpin spent most of his time teaching at Cheam School where he was a reforming headmaster dedicated to the promotion of a general education within a disciplined framework of the core subjects. Among his many innovations he provided the boys with a first rate training in drawing, assisted by his brother, the sporting artist Sawrey Gilpin, and introduced them to Cozens' 'blot' method of composition. Cozens was drawing master at nearby Eton. Having established the school on a sound footing by the early 1760's, Gilpin began to draw in pencil, wash and, occasionally, watercolour again and to undertake a series of tours of Britain which were to provide the material for his famous published works.

From 1768 Gilpin conducted an annual summer tour of a different region of Britain, writing and drawing as he went in great detail. His many surviving notebooks from these trips give a fascinating insight not only into his views about scenery and art but also about the conditions in which such travel might be conducted, with details of coaching

inns, private collections of art and road conditions. He could be scathing about what he considered lapses in architectural and landscaping taste and wrote freely and insightfully about his views on the merits or otherwise of various artists, from Rubens to Claude Lorrain.

It was in June 1770 that Gilpin made his journey along the Wye Valley, sailing from Ross to Chepstow. His writings from this tour show him for the first time confidently seeking to 'criticize the face of a country correctly'. It is clear from his earliest letters to friends following this trip that Gilpin found the scenery on the Welsh border far more sympathetic than that of the Thames and eastern counties he had previously toured. As a Cumbrian he was no doubt more at home with the wilder and more remote landscape, though he confessed that it was more 'finished' and 'correct' than that of his native terrain.

Observations on the River Wye and Several Parts of South Wales, &c. Relative Chiefly to Picturesque Beauty: made in the Summer of the Year 1770 *was Gilpin's first publication in his series of tours and appeared in a first edition of 700 copies during the summer of 1783. (The date on the title page is 1782, revealing a delay due to problems with the aquatint illustrations by* his nephew William Sawrey Gilpin). He had circulated a number of the tours in manuscript and the popularity of this limited exposure led to a decision to publish one of them. The Wye Valley tour was preferred over the Lakes one as a shorter work which might most effectively test public reaction.*

It begins with some advice on the general purpose of 'picturesque' travel and then takes a route beginning in Surrey and moving through Oxfordshire and the vale of Severn to the Wye Valley. Once at his first main destination Gilpin alternates between descriptions of specific sites such as Tintern Abbey and Chepstow and general remarks on topics such as the weather and 'natural composition'. The second half of the book carries on through South Wales and returning via Cardiff and Bristol to Hounslow Heath just west of London near where Heathrow airport now is.

The reaction of the public to Gilpin's new kind of book was very positive, although it was also one of a little puzzlement among many that the illustrations were rarely topographically exact, but rather exemplars of Gilpin's ideas about the 'picturesque'. Gilpin later wrote to his sceptical publisher William Mason: 'I did all I could to make people believe they were general ideas, or illustrations, or any thing, but, what they would have them to be, exact portraits; which

I had neither time to make, nor opportunity, nor perhaps ability; for I am so attached to my picturesque rules, that if nature gets wrong, I cannot help putting her right'.

What were these 'picturesque rules' which Gilpin put above naturalistic accuracy? He was not a philosopher and his approach was largely æsthetic, sentimental and, if paradoxically, empirical. It is best, therefore, to look at his text for some of the examples he chooses to embody his ideas. Perhaps the defining passage which best encapsulates Gilpin's general outlook is the following description of the pleasures to be derived from contemplating the setting of Tintern Abbey:

A more pleasing retreat could not easily be found. The woods, and glades intermixed; the winding of the river; the variety of the ground; the splendid ruin, contrasted with the objects of nature; and the elegant line formed by the summits of the hills, which include the whole; make all together a very enchanting piece of scenery.

'Enchantment' is the key term here for Gilpin, who finds at the Abbey a medieval monastic calm simply by immersion in the prospect. Certain views from certain positions and distances may afford a unified but varied and harmonious composition reminiscent of the finest works of art. In fact one soon realises in reading Gilpin how right he was to admit to his earnest 'attachment' to his 'picturesque rules'. While directing his readers to specific locations, often pointing out their historical associations, he simultaneously seems to return them to the drawing room with its books and paintings. In taking his travelling audience into the outside world he reassures them about their interior needs and inclinations. Gilpin becomes disturbed by all those features which distract from what is essentially an idealised view of the scenery before him. The ironworks close to the Abbey introduce 'noise and bustle into these regions of tranquillity'; and a nearby hamlet with its 'shabby houses' and impoverished inhabitants were an unpleasant distraction from an otherwise idyllic scene. Gilpin's proposal was to take a route which carefully avoided such things and to adopt a viewpoint which effectively obliterated the presence of the ironworks.

A telling passage about the ruins of the Abbey shows how far Gilpin was prepared to go to express his misgivings about the reality of a chosen view. The following description is as notorious today as any expression of polite taste from the eighteenth century:

Though the parts are beautiful, the whole is ill-shaped. No ruins of the tower are left, which might give form, and contrast to the walls, and buttresses, and other interior parts. Instead of this, a number of gable-ends hurt the eye with their regularity; and disgust it by the vulgarity of their shape. A mallet judiciously used (but who durst use it?) might be of service in fracturing some of them; particularly those of the cross aisles, which are not only disagreeable in themselves, but confound the perspective.

Gilpin dislikes the 'regularity' of the gable ends which to his eye seem to destroy the pleasing irregularity of his imagined Gothic ruin. The 'improvements' of the landowner, the Duke of Beaufort, were to Gilpin no such things, weakening the effect he desired of 'rough', 'wild' 'rudeness'. Where the conventional classical landscape required smoothness and unbroken lines of composition, Gilpin's picturesque demanded roughness and broken lines. It is a rococo taste in essence and has much in common with the views adumbrated by Hogarth in his Analysis of Beauty *of 1753.*

Tourism of course brought wealth to the remote region of the Wye Valley and in its wake a ragged population of beggars hoping for charity and offering guided tours. Gilpin, a gentle Anglican priest, was struck by a woman at Tintern Abbey who 'could scarce crawl, shuffling along her palsied limbs' and offering to show him the remains of the monk's library. He is touched that this turns out to be 'her own mansion' and that her story is not of cloistered life but of her own sad decline. 'We did not expect to be interested: but we found we were'. Among writers of such books, Gilpin was almost unique in finding such an experience of any value. Most pulled a discreet veil over the unpleasing realities of rural deprivation as they directed their audiences about the country. Gilpin's polite æsthetic, however, domesticating and taming the natural and social landscape quite easily became the basis for an explicitly conservative view of the landscape and society developed by Richard Payne Knight and Uvedale Price in the 1790's. By the early nineteenth century Gilpin was mocked by William Combe's satirical poem Dr Syntax *as a bumbling fool, brilliantly visualised in Thomas Rowlandson's accompanying caricatures. Yet his legacy was assured and his tours remain charming insights into the new world of the middle class traveller in a changing Britain.*

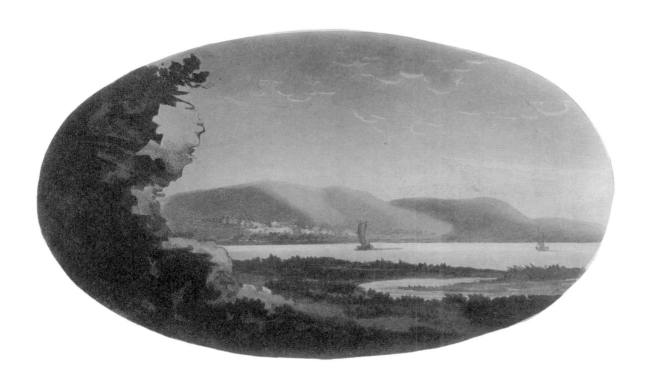

The Rev. WILLIAM MASON.

DEAR SIR,

THE very favourable manner in which you spoke of some observations I shewed you in MS. several years ago, *On the lakes and mountains of the northern parts of England,** induced many of my friends at different times to desire the publication of them. But as they are illustrated by a great variety of drawings, the hazard and expense had rather a formidable appearance. A subscription was mentioned to me, and the late duchess dowager of Portland, with her usual generosity, sent me a hundred pounds as a subscription from herself: but I could not accept her grace's kindness, as I was still afraid of an *engagement with the public.*

You advised me to make an essay in a smaller

work of the same kind, which might enable me the better to ascertain the expenses of a larger. I have followed your advice, and have chosen the following little piece for that purpose, which was the first of the kind I ever amused myself with; and as it is very unimportant in itself, you will excuse my endeavouring to give it some little credit by the following anecdote.

In the same year in which this journey was made, your late valuable friend Mr. Gray* made it

* See Gray's *Memoirs,* p. 377.

* Mr. Gray's account of this tour is contained in a letter, dated the 24th of May 1771:

My last summer's tour was through Worcestershire, Gloucestershire, Monmouthshire, Herefordshire, and Shropshire, five of the most beautiful counties in the kingdom. The very principal light, and capital feature of my journey, was the river Wye, which I descended in a boat for near forty miles from Ross to Chepstow. Its banks are a succession of nameless beauties. One out of many you may see

likewise, and hearing that I had put on paper a few remarks on the scenes which he had so lately visited, he desired a sight of them. They were then only in a rude state: but the handsome things he said of them to a friend† of his, who obligingly repeated them to me, gave them some little degree of credit in my own opinion, and made me somewhat less apprehensive in risking them before the public.

If this little work afforded any amusement to Mr. Gray, it was the amusement of a very late period of his life. He saw it in London about the beginning of June 1771, and he died, you know, at the end of the July following.

Had he lived, it is possible, he might have been induced to have assisted me with a few of his own remarks on scenes which he had so accurately examined. The slightest touches of such a master would have had their effect; no man was a greater admirer of nature than Mr. Gray, nor admired it with better taste.

I can only however offer this little work to the public as a hasty sketch. A country should be seen often to be seen correctly; it should be seen also in various seasons; different circumstances make such changes in the same landscape, as give it wholly a new aspect. But these scenes are marked just as they struck the eye at first; I had no opportunity to repeat the view.

For the drawings I must apologise in the same manner. They were hastily sketched, and under many disadvantages; and pretend at best to give only a general idea of a place or scene, without entering into the details of portrait.

not ill-described by Mr. Whately, in his observations on gardening, under the name of the New Weir. He has also touched on two others, Tintern Abbey and Persfield, both of them famous scenes, and both on the Wye. Monmouth, a town I never heard mentioned, lies on the same river in a vale that is the delight of my eyes, and the very seat of pleasure. The vale of Abergavenny, Raglan and Chepstow Castles, Ludlow, Malvern Hills. &c. were the rest of my acquisitions, and no bad harvest in my opinion: but I made no Journal myself, else you should have had it. I have indeed a short one, written by the companion of my travels, Mr. Nicholls, that serves to recall and fix the fleeting images of these things.

†William Fraser, Esq. under-secretary of state.

I do not myself thoroughly understand the process of working in aqua-tinta; but the great inconvenience of it seems to arise from its not being sufficiently under the artist's command. It is not always able to give that just *gradation* of light and shade, which he desires. Harsh edges will sometimes appear. It is however a very beautiful mode of multiplying drawings; and certainly comes nearer than any other to the softness of the pencil. It may indeed literally be called *drawing*; as it washes in the shades. The only difference is, that it is a more unmanageable process to wash the shades upon copper with aqua-fortis, than upon paper with a brush. If however the aqua-tinta method of multiplying drawings hath some inconveniences, it is no more than every other mode of working on copper is subject to — engraving, particularly, is always accompanied with a degree of stiffness.

For myself, I am most pleased with the free, rough style of etching landscape with a needle, after the manner of Rembrandt, in which much is left to the imagination to make out. But this would not satisfy the public; nor indeed anyone, whose imagination is not so conversant with the scenes of nature, as to make out a landscape from a hint. This rough work hath, at least, the advantage of biting the copper more strongly, and giving a greater number of good impressions.

Believe me to be, dear sir, with great regard and esteem,

Your very sincere,
And affectionate

WILLIAM GILPIN

VICAR'S HILL,
November 20, 1782.

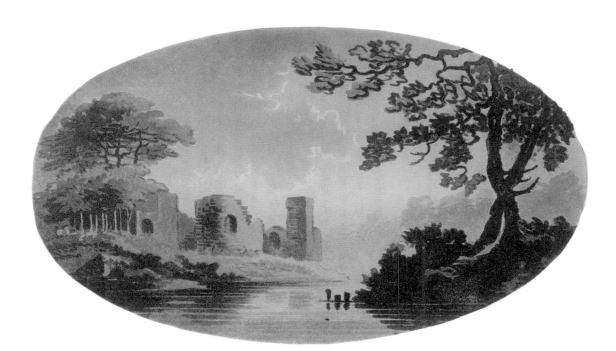

OBSERVATIONS
ON THE
RIVER WYE, &c.

———◆———

We travel for various purposes — to explore the culture of soils, to view the curiosities of art, to survey the beauties of nature, and to learn the manners of men, their different politics and modes of life.

The following little work proposes a new object of pursuit; that of examining the face of a country *by the rules of picturesque beauty*; opening the sources of those pleasures which are derived from the comparison.

Observations of this kind, through the vehicle of description, have the better chance of being founded in truth, as they are not the offspring of theory, but are taken immediately from the scenes of nature as they arise.

Crossing Hounslow Heath from Kingston in Surrey, we struck into the Reading road; and turned a little aside to see the approach to Caversham House, which winds about a mile along a valley through the park. This was the work of Brown, whose great merit lay in pursuing the path which nature had marked out. Nothing can be easier than the sweep, better united than the ground, or more ornamental than several of the clumps; but many of the single trees, which are beeches, are heavy, and offend the eye. Almost any ordinary tree may contribute to form a group. Its deformities are lost in a crowd; nay, even the deformities of one tree may be corrected by the deformities of another. But few trees have those characters of beauty which will enable them to appear with advantage as individuals.*

* This approach to Caversham House, I have been informed, is now much injured.

From Lord Cadogan's we took the Wallingford road to Oxford. It affords some variety, running along the declivity of a range of hills; and overlooking one of the valleys of the Thames. But these scenes afford nothing very interesting. The Thames appears; but only in short reaches. It rarely exceeds the dimensions of a pool; and does not once, as I remember, exhibit those ample sweeps, in which the beauty of a river so much consists. The woods too are frequent; but they are formal copses: and white spots, bursting everywhere from a chalky soil, disturb the eye.

From Wallingford to Oxford, we did not observe one good view, except at Shillingford: where the bridge, the river, and its woody banks exhibit some scenery.

From Oxford we proposed to take the nearest road to Ross. As far as Witney, the country appears flat, though in fact it rises. About the eleventh stone the high grounds command a noble semi-circular distance on the left; and near Burford there are views of the same kind on the right; but not so extensive. None of these landscapes however are perfect, as they want the accompaniments of foregrounds.

At Mr. Lenthal's, in Burford, we admired a capital picture of the family of the Mores, which is said to be Holbein's; and appeared to us entirely in that master's style. But Mr. Walpole thinks it not an original; and says he found a date upon it subsequent to the death of that master. It is however a good picture of its kind. It contains eleven figures—Sir Thomas More, and his father; two young ladies, and other branches of the family. The heads are as expressive, as the composition is formal. The judge is marked with the character of a dry, facetious, sensible, old man. The chancellor is handed down to us in history, both as a cheerful philosopher, and as a severe inquisitor. His countenance here has much of that eagerness and stern attention which remind us of the latter. The subject of this piece seems to be a dispute between the two young ladies; and alludes probably to some well-known family story.

Indeed every family picture should be founded on some little story or domestic incident, which, in a

degree, should engage the attention of all the figures. It would be invidious perhaps to tax Van Dyck on this head; otherwise I could mention some of his family-pictures, which, if the sweetness of his colouring and the elegant simplicity of his airs and attitudes did not screen his faults, would appear only like so many distinct portraits stuck together on the same canvas. It would be equally invidious to omit mentioning a modern master, now at the head of his profession*, whose great fertility of invention in *employing* the figures of his family pictures, is not among the least of his many excellences.

The country from Burford is high, and downy. A valley, on the right, kept pace with us; through which flows the Windrush; not indeed an object of sight, but easily traced along the meadows by pollard-willows, and a more luxuriant vegetation.

At Barrington we had a pleasant view, through an opening on the foreground.

About Northleach the road grows very disagreeable. Nothing appears but downs on each side; and

* Sir Joshua Reynolds

these often divided by stone walls, the most offensive separation of property.

From the neighbourhood of London we had now pursued our journey through a tract of country almost uniformly rising, though by imperceptible degrees, into the heart of Gloucestershire; till at length we found ourselves on the ridge of Cotswold.

The county of Gloucester is divided into three capital parts: the Wolds, or high downy grounds towards the east, the vale of Severn in the middle, and the forest of Dean towards the west. The first of these tracts of country we had been traversing from our entrance into Gloucestershire; and the ridge we now stood on made the extremity of it. Here the heights which we had been ascending by imperceptible degrees, at length broke down abruptly into the lower grounds; and a vast stretch of distant country appeared at once before the eye.

I know not that I was ever more struck with the singularity and grandeur of any landscape. Nature generally brings several countries together in some easy mode of connection. If she raise the grounds on

one side by a long ascent, she commonly unites them with the country on the other in the same easy manner. Such scenes we view without wonder or emotion. We glide without observation from the near grounds into the more distant. All is gradual and easy. But when nature works in the bold and singular style of composition in which she works here; when she raises a country through a progress of a hundred miles, and then breaks it down at once by an abrupt precipice into an expansive vale, we are immediately struck with the novelty and grandeur of the scene.

It was the vale of Severn which was spread before us. Perhaps nowhere in England a distance so rich, and at the same time so extensive, can be found. We had a view of it almost from one end to the other, as it wound through the space of many leagues in a direction nearly from west to north. The eye was lost in the profusion of objects which were thrown at once before it, and ran wild over the vast expanse with rapture and astonishment, before it could compose itself enough to make any coherent observations. At length we began to examine the detail, and to separate the vast immensity before us into parts.

To the north, we looked up the vale along the course of the Severn. The town of Cheltenham lay beneath our feet, then at the distance of two or three miles. The vale appeared afterwards confined between Bredon hills on the right, and those of Malvern on the left. Right between these in the middle of the vale, lay Tewkesbury, bosomed in wood: the great church, even at this distance, made a respectable appearance. A little to the right, but in distance very remote, we might see the towers of Worcester, if the day were clear; especially if some accidental gleam of light relieved them from the hills of Shropshire, which close the scene.

To the west, we looked toward Gloucester. And here it is remarkable, that as the objects in the northern part of the vale are confined by the hills of Malvern and Bredon, so in this view the vale is confined by two other hills, which, though inconsiderable in themselves, give a character to the scene; and the more so as they are both insulated. One of these hills is known by the name of Robin's Wood; the other by that of Churchdown, from the singularity of a church seated on its eminence. Between these hills

the great object of the vale is the city of Gloucester, which appeared rising over rich woody scenes. Beyond Gloucester the eye still pursued the vale into remote distance, till it united with a range of mountains.

Still more to the west, arose a distant forest-view, composed of the woods of the country uniting with the forest of Dean. Of this view the principal feature is the mouth of the Severn, where it first begins to assume a character of grandeur by mixing with the ocean.

We see only a small portion of it stretching in an acute angle over a range of wood. But an eye used to perspective, seeing such a body of water, small as it appears, wearing any *determined form* at such a distance, gives it credit for its full magnitude. The Welsh mountains also, which rise beyond the Severn, contributed to raise the idea; for by forming an even horizontal line along the edge of the water, they gave it the appearance of what it really is, an arm of the sea.

Having thus taken a view of the vast expanse of the vale of Severn from the extremity of the descent of Cotswold, we had leisure next to examine the grandeur of the descent itself; which forms a foreground not less admirable than the distance. The lofty ridge on which we stood is of great extent; stretching beyond the bounds of Gloucestershire, both towards the north and towards the south. It is not everywhere, we may suppose, of equal beauty, height, and abruptness: but fine passages of landscape, I have been told, abound in every part of it. The spot where we took this view over the vale of Severn, is the high ground on Crickley Hill; which is a promontory standing out in the vale between the villages of Leckhampton and Birdlip. Here the descent consists of various rocky knolls, prominences, and abruptnesses; among which a variety of roads wind down the steep towards different parts of the vale; and each of these roads, through its whole varying progress, exhibits some beautiful view, discovering the vale, either in whole or in part, with every advantage of a picturesque foreground.

Many of these precipices also are finely wooded. Some of the largest trees in the kingdom, perhaps,

are to be seen in these parts. The Cheltenham oak, and an elm not far from it, are trees, which curious travellers always inquire after.

Many of these hills, which enclose the vale of Severn on this side, furnish landscapes themselves, without borrowing assistance from the vale. The woody valleys, which run winding among them, present many pleasing pastoral scenes. The clothing country about Stroud, is particularly diversified in this way: though many of these valleys are greatly injured in a picturesque light, by introducing scenes of habitation and industry. A cottage, a mill, or a hamlet among trees, may often add beauty to a rural scene: but when houses are scattered through every part, the moral sense can never make a convert of the picturesque eye. Stroudwater valley especially, which is one of the most beautiful of these scenes, has been deformed lately not only by a number of buildings, but by a canal cut through the middle of it.

Among the curiosities of these high grounds, is the seven-well-head of the Thames. In a glen near the road, a few limpid springs, gushing from a rock,

give origin to this noblest of English rivers; though I suppose several little streams in that district might claim the honour with equal justice, if they could bring over the public opinion.

Nothing can give a stronger idea of the nature of the country I have been describing, than this circumstance of its giving rise to the Thames. On one side, within half a dozen miles below the precipice, the Severn has arrived at so much consequence, as to take its level from the tides of the ocean; on the other, the Thames arising at our feet, does not arrive at that dignity, till it have performed a course of two hundred and fifty miles.

Having descended the heights of Crickley, the road through the vale continues so level to Gloucester, that we scarcely saw the town till we entered it.

The cathedral is of elegant Gothic on the outside, but of heavy Saxon within; that is, these different modes of architecture *prevail* most in these different parts of the building: for in fact, the cathedral of Gloucester is a compound of all the several modes

which have prevailed from the days of Henry II to those of Henry VII, and may be said to include, in one part or other, the whole history of sacred architecture during that period. Many parts of it have been built in the times of the purest Gothic; and others, which have been originally Saxon, appear plainly to have been altered into the Gothic; which was no uncommon practice. A Grecian screen is injudiciously introduced to separate the choir. The cloisters are light and airy.

As we leave the gates of Gloucester, the view is pleasing. A long stretch of meadow, filled with cattle, spreads into a foreground. Beyond, is a screen of wood, terminated by distant mountains; among which Malvern Hills make a respectable appearance. The road to Ross leads through a country, woody, rough, hilly, and picturesque.

Ross stands high, and commands many distant views; but that from the churchyard is the most admired, and is indeed very amusing. It consists of an easy sweep of the Wye, and of an extensive country beyond it. But it is not picturesque. It is marked by no characteristic objects: it is broken into too

many parts; and it is seen from too high a point. The spire of the church, which is the Man of Ross's heaven-directed spire, tapers beautifully. The inn, which was the house he lived in, is known by the name of 'The Man of Ross's house'.

At Ross we planned our voyage down the Wye to Monmouth; and provided a covered boat, navigated by three men. Less strength would have carried us down; but the labour is in rowing back.

THE WYE takes its rise near the summit of Plinlimmon, and, dividing the counties of Radnor and Brecon, passes through the middle of Herefordshire: it then becomes a second boundary between Monmouthshire and Gloucestershire, and falls into the Severn a little below Chepstow. To this place from Ross, which is a course of near forty miles, it flows in a gentle, uninterrupted stream; and adorns, through its various reaches, a succession of the most picturesque scenes.

The beauty of these scenes arises chiefly from

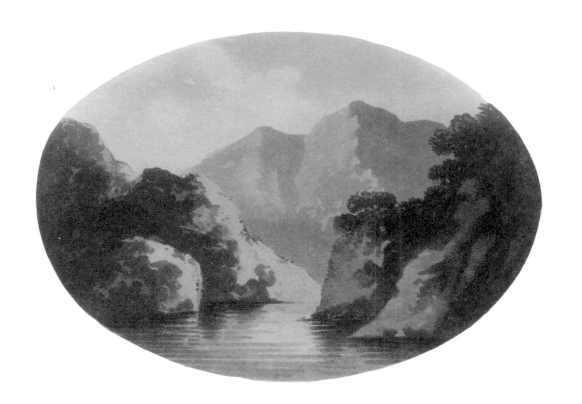

two circumstances; the *lofty banks* of the river, and its *mazy course*: both which are accurately observed by the poet, when he describes the Wye as *echoing* through its *winding* bounds*. It could not well echo, unless its banks were both lofty and *winding*.

From these two circumstances, the views it exhibits are of the most beautiful kind of perspective, free from the formality of lines.

The most perfect river-views, thus circumstanced, are composed of four grand parts: the area, which is the river itself; the two *side-screens*, which are the opposite banks, and lead the perspective; and the *front-screen*, which points out the winding of the river.

If the Wye ran, like a Dutch canal, between parallel banks, there could be no front-screen: the two side screens, in that situation, would lengthen to a point.

If a road were under the circumstance of a river winding like the Wye, the effect would be the same. But this is rarely the case. The road pursues the irregularity of the country. It climbs the hill, and

sinks into the valley; and this irregularity gives each view it exhibits a different character.

The views on the Wye, though composed only of these *simple parts*, are yet *exceedingly varied*.

They are varied, first, by the *contrast of the screens*: sometimes one of the side-screens is elevated, sometimes the other, and sometimes the front; or both the side-screens may be lofty, and the front either high or low.

Again, they are varied by the *folding of the side-screens over each other*; and hiding more or less of the front. When none of the front is discovered, the folding side either winds round, like an amphitheatre,* or it becomes a long reach of perspective.

These *simple* variations admit still farther variety from becoming *complex*. One of the sides may be compounded of various parts, while the other remains simple; or both may be compounded, and the front simple; or the front alone may be compounded.

*Pleas'd Vaga echoes thro' its winding bounds,
And rapid Severn hoarse applause resounds. Pope's *Moral Essays*

* The, word *amphitheatre*, strictly speaking, is a complete enclosure; but, I beleive, it is commonly accepted, as here, for any circular piece of architecture, though it do not wind *entirely* round.

Besides these sources of variety, there are other circumstances, which, under the name of *ornaments*, still farther increase them. Plain banks will admit all the variations we have yet mentioned; but when this *plainness* is *adorned*, a thousand other varieties arise.

The *ornaments* of the Wye may be ranged under four heads: *ground*, *wood*, *rocks*, and *buildings*.

The *ground*, of which the banks of the Wye consist (and which have thus far been considered only in its *general effect*), affords every variety which ground is capable of receiving; from the steepest precipice to the flattest meadow. This variety appears in the line formed by the summits of the banks; in the swellings and excavations of their declivities; and in their indentations at the bottom, as they unite with the water.§

In many places also the ground is *broken*; which adds new sources of variety. By *broken ground*, we mean only such ground as hath lost its turf, and discovers the naked soil. We often see a gravelly earth shivering from the hills, in the form of water-falls: often dry, stony channels, guttering down precipices, the rough beds of temporary torrents; and sometimes so trifling a cause as the rubbing of sheep against the sides of little banks or hillocks, will occasion very beautiful breaks.

The *colour* too of the broken soil is a great source of variety; the yellow or the red ochre, the ashy grey, the black earth, or the marly blue: and the intermixtures of these with each other, and with patches of verdure, blooming heath, and other vegetable tints, still increase that variety.

Nor let the fastidious reader think these remarks descend too much in detail. Were an extensive distance described, a forest scene, a sea-coast view, a vast semi-circular range of mountains, or some other grand display of nature, it would be trifling to mark these minute circumstances. But here the hills around exhibit little except *foregrounds*; and it is necessary, where we have no distances, to be more exact in finishing objects at hand.

The next great ornament on the banks of the Wye are its woods. In this country are many works

§ This is where Gilpin placed Plate 1 (page 2 of this edition)

carried on by fire; and the woods being maintained for their use, are periodically cut down. As the larger trees are generally left, a kind of alternacy takes place: what is this year a thicket, may the next be an open grove. The woods themselves possess little beauty, and less grandeur ; yet, as we consider them merely as the *ornamental* parts of a scene, the eye will not examine them with exactness, but compound for a *general effect*.

One circumstance attending this alternacy is pleasing. Many of the furnaces on the banks of the river consume charcoal, which is manufactured on the spot; and the smoke issuing from the sides of the hills, and spreading its thin veil over a part of them, beautifully breaks their lines, and unites them with the sky.

The chief deficiency, in point of wood, is of large trees on the *edge of the water;* which, clumped here and there, would diversify the hills as the eye passes them; and remove that heaviness which always, in some degree (though here as little as anywhere), arises from the continuity of ground. They would also give a degree of distance to the more removed parts; which in a scene like this, would be attended with peculiar advantage: for as we have here so little distance, we wish to make the most of what we have. But trees *immediately on the foreground* cannot be suffered in these scenes, as they would obstruct the navigation of the river.§

The *rocks*, which are continually starting through the woods, produce another *ornament* on the banks of the Wye. The rock, as all other objects, though more than all, receives its chief beauty from contrast. Some objects are beautiful in themselves. The eye is pleased with the tuftings of a tree: it is amused with pursuing the eddying stream; or it rests with delight on the broken arches of a Gothic ruin. Such objects, independent of composition, are beautiful in themselves. But the rock, bleak, naked, and unadorned, seems scarcely to deserve a place among them. Tint it with mosses and lichens of various hues, and you give it a degree of beauty. Adorn it with shrubs and hanging herbage, and

§ This is where Gilpin placed Plate 9 (page 12 of this edition)

you make it still more picturesque. Connect it with wood, and water, and broken ground, and you make it in the highest degree interesting. Its *colour* and its *form* are so accommodating, that it generally blends into one of the most beautiful appendages of landscape.

Different kind of rocks have different degrees of beauty. Those on the Wye, which are of a greyish colour, are in general simple and grand; rarely formal or fantastic. Sometimes they project in those beautiful square masses, yet broken and shattered in every line, which is characteristic of the most majestic species of rock. Sometimes they slant obliquely from the eye in shelving diagonal strata: and sometimes they appear in large masses of smooth stone, detached from each other, and half buried in the soil. Rocks of this last kind are the most lumpish, and the least picturesque.

The various *buildings* which arise everywhere on the banks of the Wye, form the last of its *ornaments*: abbeys, castles, villages spires, forges, mills, and bridges. One or other of these venerable vestiges of past, or cheerful habitations of present times, characterize almost every scene.

These *works* of art are, however, of much greater use in *artificial* than in *natural* landscape. In pursuing the beauties of nature, we range at large among forests, lakes, rocks, and mountains. The various scenes we meet with, furnish an inexhausted source of pleasure: and though the works of art may often give animation and contrast to these scenes, yet still they are not necessary: we can be amused without them. But when we introduce a scene on canvas, when the eye is to be confined within the frame of a picture, and can no longer range among the varieties of nature, the aids of art become more important; and we want the castle or the abbey, to give consequence to the scene. Indeed the landscape painter seldom thinks his view perfect without characterizing it by some object of this kind.

SECTION III

HAVING thus analyzed the Wye, and considered separately its constituent parts; the steepness of its

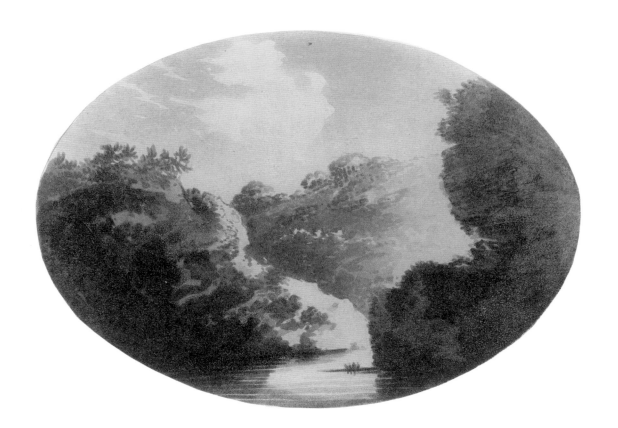

banks, its mazy course, the grounds, woods and rocks, which are its native ornaments; and the buildings, which still further adorn its natural beauties; we shall now take a view of some of those pleasing scenes which result from the *combination* of all these picturesque materials.

I must, however, premise how ill-qualified I am to do justice to the banks of the Wye, were it only from having seen them under the circumstance of a continued rain, which began early in the day, before one third of our voyage was performed.

It is true, scenery at *hand* suffers less under such a circumstance, than scenery at a *distance*, which it totally obscures.

The picturesque eye also, in quest of beauty, finds it almost in every incident and under every appearance of nature. Even the rain gave a gloomy grandeur to many of the scenes; and by throwing a veil of obscurity over the removed banks of the river, introduced, now and then, something like a pleasing distance. Yet still it hid greater beauties; and we could not help regretting the loss of those broad lights and deep shadows which would have given so much lustre to the whole, and which ground like this is in a peculiar manner adapted to receive.

The first part of the river from Ross is tame. The banks are low; and scarcely an object attracts the eye, except the ruins of Wilton Castle, which appear on the left, shrouded with a few trees. But the scene wants accompaniments to give it grandeur.§

The bank, however, soon began to swell on the right, and was richly adorned with wood. We admired it much; and also the vivid images reflected from the water, which were continually disturbed as we sailed past them, and thrown into tremulous confusion by the dashing of our oars. A disturbed surface of water endeavouring to collect its scattered images and restore them to order, is among the *pretty* appearances of nature.

We met with nothing for some time during our voyage but these grand woody banks, one rising

§ This is where Gilpin placed Plate 3 (page 16 of this edition)

behind another; appearing and vanishing by turns, as we doubled the several capes. But though no particular objects characterized these different scenes, yet they afforded great variety of pleasing views, both as we wound round the several promontories, which discovered new beauties as each scene opened, and when we kept the same scene a longer time in view, stretching along some lengthened reach, where the river is formed into an irregular vista by hills shooting out beyond each other, and going off in perspective.

The channel of no river can be more decisively marked than that of the Wye. *Who hath divided a water-course for the flowing of rivers?* saith the Almighty in that grand apostrophe to Job on the works of creation. The idea is happily illustrated here. A nobler *water-course* was never *divided* for any river than this of the Wye. Rivers, in general, pursue a devious course along the countries through which they flow; and form channels for themselves by constant fluxion. But sometimes, as in these scenes, we see a channel marked with such precision, that it appears as if originally intended only for the bed of a river.

After sailing four miles from Ross, we came to Goodrich Castle; where a grand view presented itself; and we rested on our oars to examine it. A reach of the river, forming a noble bay, is spread before the eye. The bank, on the right, is steep, and covered with wood; beyond which a bold promontory shoots out, crowned with a castle, rising among trees.

This view, which is one of the grandest on the river, I should not scruple to call *correctly picturesque*; which is seldom the character of a purely natural scene.

Nature is always great in design. She is an admirable colourist also; and harmonizes tints with infinite variety and beauty: but she is seldom so correct in composition, as to produce an harmonious whole. Either the foreground or the background is disproportioned; or some awkward line runs across the piece; or a tree is ill-placed; or a bank is formal; or something or other is not exactly what it should be. The case is, the immensity of nature is beyond human comprehension. She works on a *vast scale*; and, no doubt harmoniously, if her schemes could be comprehended. The artist, in the meantime, is

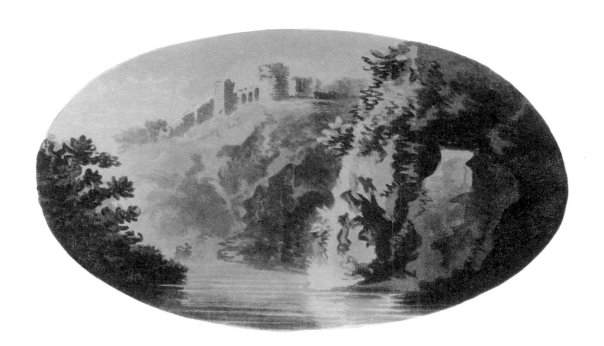

confined to a *span*; and lays down his little rules, which he calls the *principles of picturesque beauty*, merely to adapt such diminutive parts of nature's surfaces to his own eye as come within its scope. —Hence, therefore, the painter who adheres strictly to the *composition* of nature, will rarely make a good picture. His picture must contain a *whole*; his archetype is but a part. In general, however, he may obtain views of such parts of nature, as with the addition of a few trees or a little alteration in the foreground, (which is a liberty that must always be allowed), may be adapted to his rules; though he is rarely so fortunate as to find a landscape so completely satisfactory to him. In the scenery indeed at Goodrich Castle the parts are few; and the whole is a simple exhibition. The complex scenes of nature are generally those which the artist finds most refractory to his rules of composition.

In following the course of the Wye, which makes here one of its boldest sweeps, we were carried almost round the castle, surveying it in a variety of forms. Some of these retrospects are good; but, in general, the castle loses, on this side, both its own dignity and the dignity of its situation.

The views *from* the castle were mentioned to us as worth examining; but the rain was now set in, and would not permit us to land.

As we left Goodrich Castle, the banks on the left, which had hitherto contributed less to entertain us, began now principally to attract our attention, rearing themselves gradually into grand steeps; sometimes covered with thick woods, and sometimes forming vast concave slopes of mere verdure; unadorned, except here and there, by a straggling tree; while the sheep which hang browsing upon them, seen from the bottom, were diminished into white specks.

The view at Ruardean Church unfolds itself next; which is a scene of great grandeur. Here both sides of the river are steep, and both woody; but in one the woods are intermixed with rocks. The deep umbrage of the Forest of Dean occupies the front; and the spire of the church rises among the trees. The reach of the river which exhibits this scene is

long; and, of course, the view, which is a noble piece of natural perspective, continues some time before the eye: but when the spire comes directly in front, the grandeur of the landscape is gone.

The stone quarries on the right, from which Bristol Bridge was built, and on the left the furnaces of Bishop's Wood, vary the scene; though they are objects of no great importance in themselves.

For some time both sides of the river continue steep and beautiful. No particular circumstance indeed characterizes either: but in such exhibitions as these nature characterizes her own scenes. We admire the infinite *variety* with which she *shapes* and *adorns* these vast concave and convex forms. We admire also that varied touch with which she expresses every object.

Here we see one great distinction between *her* painting and that of all her *copyists*. Artists universally are *mannerists* in a certain degree. Each has his particular mode of forming particular objects. His rocks, his trees, his figures, are cast in one mould; at least they possess only a *varied sameness*. The figures of Rubens are all full-fed; those of Salvator spare

and long-legged: but nature has a different mould for every object she presents.

The artist again discovers as little variety in filling up the surfaces of bodies, as he does in delineating their forms. You see the same touch, or something like it, universally prevail; though applied to different subjects. But nature's touch is as much varied as the form of her objects.

In every part of painting except execution, an artist may be assisted by the labours of those who have gone before him. He may improve his skill in composition, in light and shade, in perspective, in grace and elegance; that is, in all the scientific parts of his art. But with regard to *execution*, he must set up on his own stock. A mannerist, I fear, he must be. If he get a manner of his own, he may be an agreeable mannerist; but if he copy another's, he *will certainly* be a formal one. The more closely he copies the detail of nature, the better chance he has of being free from this general defect.

At Lydbrook is a large wharf, where coals are shipped for Hereford and other places. Here the

scene is new and pleasing. All has thus far been grandeur and tranquillity. It continues so yet; but mixed with life and bustle. A road runs diagonally along the bank; and horses and carts appear passing to the small vessels which lie against the wharf to receive their burdens. Close behind a rich woody hill hangs sloping over the wharf, and forms a grand background to the whole. The contrast of all this business, the engines used in lading and unlading, together with the variety of the scene, produce all together a picturesque assemblage. The sloping hill is the front-screen; the two side-screens are low.

But soon the front becomes a lofty side-screen on the left; and sweeping round the eye at Welsh Bicknor, forms a noble amphitheatre.

At Coldwell the front-screen first appears as a woody hill, swelling to a point. In a few minutes, it changes its shape, and the woody hill becomes a lofty side-screen on the right; while the front unfolds itself into a majestic piece of rock-scenery.

Here we should have gone on shore and walked to the New Weir, which by land is only a mile; though, by water, I believe, it is three. This walk would have afforded us, we were informed, some very noble river-views: nor should we have lost any thing by relinquishing the water, which in this part was uninteresting.

The whole of this information we should probably have found true, if the weather had permitted us to profit by it. The latter part of it was certainly well founded; for the water-views in this part were very tame. We left the rocks and precipices behind, exchanging them for low banks and sedges.

But the grand scenery soon returned. We approached it, however, gradually. The views at Whitchurch were an introduction to it. Here we sailed through a long reach of hills, whose sloping sides were covered with large, lumpish, detached stones; which seemed, in a course of years, to have rolled from a girdle of rocks that surrounds the upper regions of these high grounds on both sides of the river; but particularly on the left.

From these rocks we soon approached the New-Weir, which may be called the second grand scene on the Wye.

The river is wider than usual in this part; and

WILLIAM GILPIN

takes a sweep round a towering promontory of rock; which forms the side-screen on the left, and is the grand feature of the view. It is not a broad fractured face of rock; but rather a woody hill, from which large rocky projections, in two or three places, burst out; rudely hung with twisting branches and shaggy furniture, which, like mane round the lion's head, give a more savage air to these wild exhibitions of nature. Near the top a pointed fragment of solitary rock, rising above the rest, has rather a fantastic appearance; but it is not without its effect in marking the scene. A great master in landscape has adorned an imaginary view with a circumstance exactly similar:

Stabat acuta silex, praecisis undiq; saxis,
—— dorso insurgens, altissima visu,
Dirarum nidis domus opportune volucrum,
—— prona jugo, lævum incumbebat ad amnem. *
Æneid, Bk. VIII

* On the left of the river stood a lofty rock, as if hewn from the quarry, hanging over the precipice, haunted by birds of prey.

36

But the most wonderful appearance of this kind I ever met with, is to be found in the 249th page of Mr. Anderson's *Narrative of the British Embassy to China*; where he tells us, that in Tartary, beyond the wall, he saw a solitary rock of this kind, which rose from the summit of a mountain at least one hundred feet. Its base was somewhat smaller than its superstructure; and, what was very extraordinary, several streams of water issued from it.

On the right side of the Wye, opposite the rock we have just described, the bank forms a woody amphitheatre, following the course of the stream round the promontory. Its lower skirts are adorned with a hamlet, in the midst of which, volumes of thick smoke, thrown up at intervals from an iron forge, as its fires receive fresh fuel, add double grandeur to the scene.

But what peculiarly marks this view, is a circumstance on the water. The whole river at this place makes a precipitate fall; of no great height indeed, but enough to merit the name of a cascade; though to the eye, above the stream, it is an object of no consequence. In all the scenes we had yet passed,

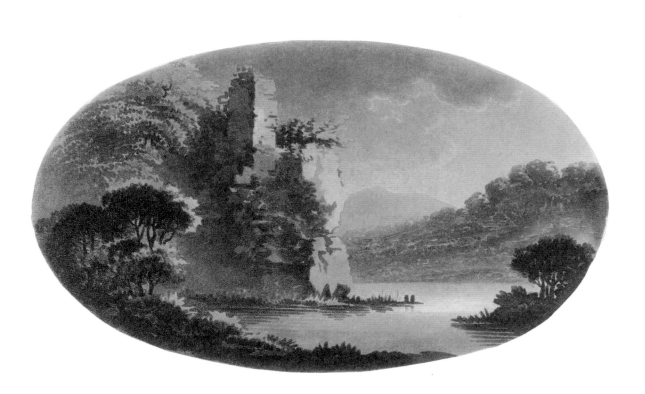

the water, moving with a slow and solemn pace, the objects around kept time, as it were, with it; and every steep and every rock which hung over the river, was awful, tranquil, and majestic. But here the violence of the stream and the roaring of the waters impressed a new character on the scene: all was agitation and uproar; and every steep and every rock stared with wildness and terror.

A kind of fishing boat is used in this part of the river, which is curious. It is constructed of waxed canvas stretched over a few slight ribs, and holds only a single man. It is called a *coracle*; and is derived, probably, as its name imports, from that species of ancient boat which was formed of leather.

An adventurous fellow, for a wager, once navigated a coracle as far as the isle of Lundy, at the mouth of the Bristol Channel. A full fortnight, or more, he spent in this dangerous voyage; and it was happy for him that it was a fortnight of serene weather. Many a current and many an eddy, many a flowing tide, and many an ebbing one, afforded him occasion to exert all his skill and dexterity. Sometimes his little bark was carried far to leeward,

and sometimes as far to windward; but still he recovered his course; persevered in his undertaking; and at length happily achieved it. When he returned to the New Weir, report says, the account of his expedition was received like a voyage round the world.

Below the New Weir are other rocky views of the same kind, though less beautiful. But description flags in running over such a monotony of terms. *High, low, steep, woody, rocky*, and a few others, are all the colours of language we have to describe scenes in which there are infinite gradations, and, amidst some general sameness, infinite peculiarities.

After we had passed a few of these scenes, the hills gradually descend into Monmouth, which lies too low to make any appearance from the water; but on landing, we found it a pleasant town, and neatly built. The town-house and church are both handsome.

The transmutations of time are often ludicrous. Monmouth Castle was formerly the palace of a king, and birth-place of a mighty prince: it is now converted into a yard for fatting ducks.

The sun had set before we arrived at Monmouth. Here we met our chaise; but, on inquiry, finding a voyage more likely to produce amusement than a journey, we made a new agreement with our bargemen, and embarked again the next morning.

SECTION IV

AS WE LEFT Monmouth, the banks on the left were at first low; but on both sides they soon grew steep and woody; varying their shapes as they had done the day before. The most beautiful of these scenes is in the neighbourhood of St. Briavel's Castle; where the vast woody declivities on each hand are uncommonly magnificent. The castle is at too great a distance to make any object in the view.

The weather was now serene; the sun shone; and we saw enough of the effect of light in the exhibitions of this day, to regret the want of it the day before.

During the whole course of our voyage from Ross, we had scarcely seen one cornfield. The banks of the Wye consist almost entirely either of wood or of pasturage; which I mention as a circumstance of peculiar value in landscape. Furrowed lands and waving corn, however charming in pastoral poetry, are ill accommodated to painting. The painter never desires the hand of art to touch his grounds. —But if art *must* stray among them, if it *must* mark out the limits of property, and turn them to the uses of agriculture, he wishes that these limits may, as much as possible, be concealed; and that the lands they circumscribe may approach as nearly as may be to nature; that is, that they may be pasturage. Pasturage not only presents an agreeable surface; but the cattle which graze it add great variety and animation to the scene.

The meadows below Monmouth, which ran shelving from the hills to the water-side, were particularly beautiful and well inhabited. —Flocks of sheep were everywhere hanging on their green steeps; and herds of cattle occupying the lower grounds. We often sailed past groups of them laving their sides in the water; or retiring from the heat under sheltered banks.

In this part of the river also, which now begins to widen, we were often entertained with light vessels gliding past us. Their white sails passing along the sides of woodland hills were very picturesque.

In many places also the views were varied by the prospect of bays and harbours in miniature, where little barks lay moored, taking in ore and other commodities from the mountains. These vessels, designed plainly for rougher water than they at present encountered, shewed us, without any geographical knowledge, that we approached the sea.

From Monmouth we reached, by a late breakfast hour, the noble ruin of Tintern Abbey, which belongs to the Duke of Beaufort; and is esteemed, with its appendages, the most beautiful and picturesque view on the river.

Castles and abbeys have different situations, agreeable to their respective uses. The castle, meant for defence, stands boldly on the hill; the abbey, intended for meditation, is hid in the sequestered vale.

Ah! happy thou, if one superior rock
Bear on its brow the shivered fragment huge
Of some old Norman fortress: happier far,
Ah! then most happy, if thy vale below
Wash, with the crystal coolness of its rills,
Some mould'ring abbey's ivy-vested wall.

Such is the situation of Tintern Abbey. It occupies a great eminence in the middle of a circular valley, beautifully screened on all sides by woody hills, through which the river winds its course; and the hills, closing on its entrance and on its exit, leave no room for inclement blasts to enter. A more pleasing retreat could not easily be found. The woods and glades intermixed; the winding of the river; the variety of the ground: the splendid ruin, contrasted with the objects of nature; and the elegant line formed by the summits of the hills which include the whole, make all together a very enchanting piece of scenery. Every thing around bears an air so calm and tranquil, so sequestered from the commerce of life, that it is easy to conceive, a man of warm imagination, in monkish times, might have

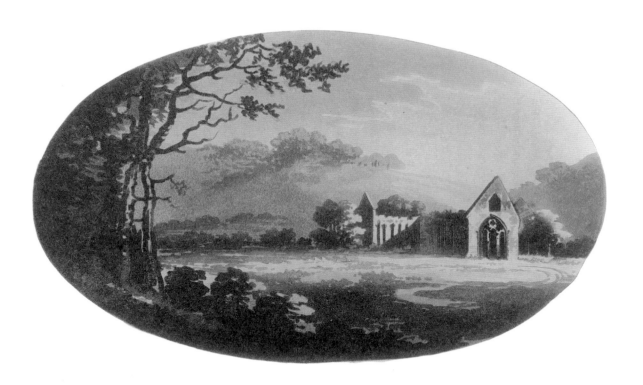

been allured by such a scene to become an inhabitant of it.

No part of the ruins of Tintern is seen from the river except the abbey church. It has been an elegant Gothic pile; but it does not make that appearance as a *distant* object which we expected. Though the parts are beautiful, the whole is ill-shaped. No ruins of the tower are left, which might give form and contrast to the buttresses and walls. Instead of this a number of gable ends hurt the eye with their regularity, and disgust it by the vulgarity of their shape. A mallet judiciously used (but who durst use it?) might be of service in fracturing some of them; particularly those of the cross-aisles, which are both disagreeable in themselves, and confound the perspective.

But were the building ever so beautiful, encompassed as it is with shabby houses, it could make no appearance from the river. From a stand near the road it is seen to more advantage.

But if Tintern Abbey be less striking as a *distant* object, it exhibits, on a *nearer* view (when the whole together cannot be seen), a very enchanting piece of ruin. The eye settles upon some of its nobler parts. Nature has now made it her own. Time has worn off all traces of the chisel: it has blunted the sharp edges of the rule and compass, and broken the regularity of opposing parts. The figured ornaments of the east window are gone; those of the west window are left. Most of the other windows, with their principal ornaments, remain.

To these were superadded the ornaments of time. Ivy, in masses uncommonly large, had taken possession of many parts of the wall; and given a happy contrast to the grey-coloured stone of which the building is composed: nor was this undecorated. Mosses of various hues, with lichens, maiden-hair, penny-leaf, and other humble plants, had overspread the surface, or hung from every joint or crevice. Some of them were in flower, others only in leaf; but all together gave those full-blown tints which add the richest finishing to a ruin.

Such is the beautiful appearance which Tintern Abbey exhibits on the *outside*, in those parts where we can obtain a nearer view of it. But when we *enter it* we see it in most perfection; at least if we

consider it as an independent object, unconnected with landscape. The roof is gone; but the walls, and pillars, and abutments which supported it are entire. A few of the pillars indeed have given way; and here and there a piece of the facing of the wall; but in corresponding parts one always remains to tell the story. The pavement is obliterated: the elevation of the choir is no longer visible: the whole area is reduced to one level, cleared of rubbish, and covered with neat turf, closely shorn; and interrupted with nothing but the noble columns which formed the aisles and supported the tower.

When we stood at one end of this awful piece of ruin, and surveyed the whole in one view, the elements of air and earth, its only covering and pavement; and the grand and venerable remains which terminated both; perfect enough to form the perspective, yet broken enough to destroy the regularity; the eye was above measure delighted with the beauty, the greatness, and the novelty of the scene. More *picturesque* it certainly would have been, if the area, unadorned, had been left with all its rough fragments of ruin scattered round; and bold was the

hand that removed them: yet as the outside of the ruin, which is the chief object of *picturesque curiosity*, is still left in all its wild and native rudeness, we excuse, perhaps we approve, the neatness that is introduced within: it *may* add to the beauty of the scene; to its *novelty* it undoubtedly does.

Among other things in this scene of desolation, the poverty and wretchedness of the inhabitants were remarkable. They occupy little huts, raised among the ruins of the monastery, and seem to have no employment but begging; as if a place once devoted to indolence could never again become the seat of industry. As we left the abbey, we found the whole hamlet at the gate, either openly soliciting alms, or covertly, under the pretence of carrying us to some part of the ruins, which each could shew, and which was far superior to anything which could be shewn by any one else. The most lucrative occasion could not have excited more jealousy and contention.

One poor woman we followed, who had engaged to shew us the monks' library. She could scarcely

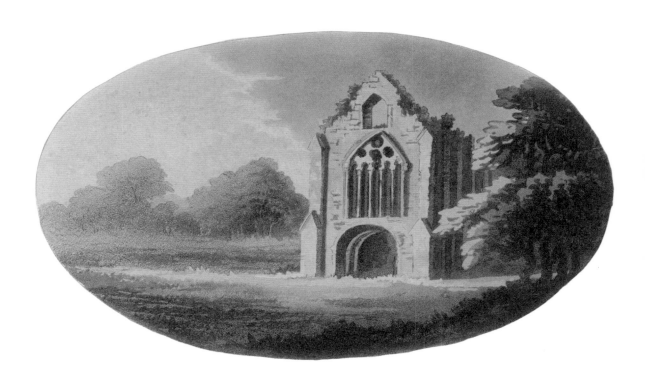

crawl; shuffling along her palsied lambs and meagre contracted body by the help of two sticks. She led us through an old gate into a place overspread with nettles and briars; and pointing to the remnant of a shattered cloister, told us that was the place. It was her own mansion. All indeed she meant to tell us was the story of her own wretchedness; and all she had to shew us, was her own miserable habitation. We did not expect to be interested as we were. I never saw so loathsome a human dwelling. It was a cavern loftily vaulted between two ruined walls, which streamed with various coloured stains of unwholesome dews. The floor was earth; yielding through moisture to the tread. Not the merest utensil or furniture of any kind appeared, but a wretched bedstead, spread with a few rags, and drawn into the middle of the cell to prevent its receiving the damp which trickled down the walls. At one end was an aperture, which served just to let in light enough to discover the wretchedness within. —When we stood in the midst of this cell of misery, and felt the chilling damps which struck us in every direction, we were rather surprised that the wretched inhabitant was still alive, than that she had only lost the use of her limbs.

The country about Tintern Abbey hath been described as a solitary tranquil silence; but its immediate environs only are meant. —Within half a mile of it are carried on great iron-works, which introduce noise and bustle into these regions of tranquillity.

The ground about these works appears from the river to consist of grand woody hills, sweeping and intersecting each other in elegant lines. They are a continuation of the same kind of landscape as that about Tintern Abbey, and are fully equal to it.

As we still descend the river, the same scenery continues: the banks are equally steep, winding, and woody; and in some parts diversified by prominent rocks, and ground finely broken and adorned.

But one great disadvantage began here to invade us. Hitherto the river had been clear and splendid; reflecting the several objects on its banks. But its waters now became oozy and discoloured. Sludgy shores too appeared on each side; and other symptoms which discovered the influence of a tide.

45

SECTION V

MR. MORRIS'S improvements at Persfield, which we soon approached, are generally thought as much worth a traveller's notice as anything on the banks of the Wye. We pushed on shore close under his rocks; and the tide being at ebb, we landed with some difficulty on an oozy beach. One of our barge-men, who knew the place, served as a guide; and under his conduct we climbed the steep by an easy regular zig-zag.

The eminence on which we stood (one of those grand eminences which overlooks the Wye) is an intermixture of rock and wood, and forms, in this place, a concave semi-circle, sweeping round in a segment of two miles. The river winds under it; and the scenery, of course, is shewn in various directions. The river itself, indeed, as we just observed, is charged with the impurities of the soil it washes; and when it ebbs its verdant banks, become slopes of mud: but if we except these disadvantages, the situation of Persfield is noble.

Little indeed was left for improvement, but to open walks and views through the woods to the various objects around them; to those chiefly of the eminence on which we stood. All this the ingenious proprietor hath done with great judgment; and hath shewn his rocks, his woods, and his precipices, under various forms, and to great advantage. Sometimes a broad face of rock is presented, stretching along a vast space, like the walls of a citadel. Sometimes it is broken by intervening trees. In other parts the rocks rise above the woods; a little farther they sink below them; sometimes they are seen through them; and sometimes one series of rocks appears rising above another: and though many of these objects are repeatedly seen, yet seen from different stations, and with new accompaniments, they appear new. The winding of the precipice is the magical secret by which all these enchanting scenes are produced.

We cannot, however, call these views picturesque. They are either presented from too high a point, or they have little to mark them as characteristic; or they do not fall into such composition as would appear to advantage on canvas. But they are

extremely romantic, and give a loose to the most pleasing riot of imagination.

These views are chiefly shewn from different stands in a close walk carried along the brow of the precipice. It would be invidious, perhaps, to remark a degree of tediousness in this walk, and too much sameness in many of its parts; notwithstanding the general variety which enlivens them: but the intention probably is not yet complete; and many things are meant to be hid, which are now too profusely shewn.*

Having seen every thing on this side of the hill, we found we had seen only half the beauties of Persfield, and pursued a walk which led us over the ridge of the eminence to the opposite side. Here the ground depositing its wild appearance, assumes a more civilized form. It consists of a great variety of lawns, intermixed with wood and rock; and, though it often rises and falls, yet it descends without any violence into the country beyond it.

The views on this side are not the romantic steeps of the Wye; but though of another species, they are equally grand. They are chiefly distances, consisting of the vast waters of the Severn, here an arm of the sea, bounded by a remote country; of the mouth of the Wye entering the Severn; and of the town of Chepstow, and its castle and abbey. Of all these distant objects an admirable use is made; and they are shewn (as the rocks of the Wye were on the other side), sometimes in parts, and sometimes altogether. In one station we had the scenery of both sides of the hill at once.

It is a pity the ingenious embellisher of these scenes could not have been satisfied with the grand beauties of nature which he commanded. The shrubberies he has introduced in this part of his improvements, I fear, will rather be esteemed paltry. As the embellishments of a house, or as the ornaments of little scenes which have nothing better to recommend them, a few flowering shrubs artfully composed may have their elegance and beauty; but in scenes like this, they are only splendid patches, which injure the grandeur and simplicity of

*As it is many years since these remarks were made, several alterations have probably, since that time, taken place.

the whole.

> —*Fortasse cupressum*
> *Scis simulare: quid hoc?—*
> —*Sit quidvis simplex duntaxat et unum.**

It is not the shrub which offends; it is the *formal introduction* of it. Wild underwood may be an appendage of the grandest scene; it is a beautiful appendage. A bed of violets or lilies may enamel the ground with propriety at the root of an oak; but if you introduce them artificially in a border, you introduce a trifling formality, and disgrace the noble object you wish to adorn.

From the scenes of Persfield we walked to Chepstow, our barge drawing too much water to pass the shallows till the return of the tide. In this walk we wished for more time than we could command, to examine the romantic scenes which surrounded us; but we were obliged to return that evening to Monmouth.

*Perhaps you may introduce some trifling plant: but does this compensate for want of unity and simplicity in a whole?

The road, at first, affords beautiful distant views of those woody hills which had entertained us on the banks of the Wye; and which appeared to as much advantage when connected with the country, as they had already done in union with the river: but the country soon loses its picturesque form, and assumes a bleak unpleasant wildness.

About seven miles from Chepstow, we had an extensive view into Wales, bounded by mountains very remote. But this view, though much celebrated, has little, except the grandeur of extension, to recommend it. And yet it is possible, that in some lights it may be very picturesque; and that we might only have had the misfortune to see it in an unfavourable one. Different lights make so great a change even in the *composition* of landscape, at least in the *apparent* composition of it, that they create a scene perfectly new. In distance, especially, this is the case. Hills and valleys may be deranged; awkward abruptnesses and hollows introduced; and the effect of woods and castles, and all the ornamental detail of a country lost. On the other hand, these ingredients of landscape may in *reality* be awkwardly introduced;

yet through the magical *influence of light*, they may be altered, softened, and rendered pleasing.

In a mountainous country particularly, I have often seen, during the morning hours, a range of hills rearing their summits, in ill-disposed fantastic shapes. In the afternoon, all this incorrect rudeness hath been removed; and each mis-shapen summit hath softened beautifully into some pleasing form.

The different seasons of the year also produce the same effect. When the sun rides high in summer, and when, in the same meridian, he just skirts the horizon in winter, he forms the mountain-tops, and indeed the whole face of a country into very different appearances.

Fogs also vary a distant country as much as light, softening the harsh features of landscape; and spreading over them a beautiful grey harmonizing tint.

We remark farther on this subject, that scarcely any landscape will stand the test of *different lights*. Some searching ray, as the sun veers round, will expose its defects. And hence it is, that almost *every* landscape is seen best under *some peculiar* illumination —either of an evening or of a morning, or, it may be, of a meridian sun.

During many miles we kept upon the heights; and, through a long and gentle descent, approached Monmouth. Before we reached it we were benighted; but as far as we could judge of a country through the grey obscurity of a summer evening, this seemed to abound with many beautiful woody valleys among the hills, which we descended. A light of this kind, though not so favorable to landscape, is very favourable to the imagination. This active power embodies half-formed images, which it rapidly combines; and often composes landscapes, perhaps more beautiful, if the imagination be well stored, than any that can be found in Nature herself. They are formed indeed from Nature — from the most beautiful of her scenes; and having been treasured up in the memory, are called into these fanciful creations by some distant resemblances which strike the eye in the multiplicity of dubious surfaces that float before it.

SECTION VI

HAVING thus navigated the Wye between Ross and Chepstow, we had such pleasing accounts of its beautiful scenery above Ross, that if our time had permitted, we could have wished to have explored it.

A journal, however, fell into my hands (since the first edition of this book was printed) of a tour to the source of the Wye; and thence through the midland counties of Wales; which I shall put into a little form; and making a few picturesque remarks, which the subject may occasionally suggest, shall insert for the benefit of those who may have more time than we had.

From Ross to Hereford the great road leaves the river, which is hardly once seen. But it is not probable that much is lost; for the whole country here has a tame appearance. The cathedral of Hereford consists, in many parts, of rich Gothic. The west front is falling fast to decay, and is every year receiving more the form of a fine ruin*.

* A subscription, I hear, is now opened to repair it.

At Hereford we again meet the Wye, of which we have several beautiful views from the higher grounds. The road now follows the course of the river to the Hay, winding along its northern banks.

About six miles from Hereford, and but little out of the road, stands Foxley. The form of the grounds about it, and the beautiful woods that surround it, are said to be worth seeing. My journalist says it contains a choice collection of pictures; and some good drawings of landscape by the late Mr. Price.

The ruins of Bredwardine Castle appear soon in view; though but little of them remains. At a bridge near them you cross the Wye, and now traverse the south side of the river. The country which had been greatly varied before, begins now to form bolder swells. Among these Meerbach Hill, which rises full in front, continues some time before the eye, as a considerable object.

Leaving Witney Bridge on the right, you still continue your course along the southern bank of the river, and come soon in view of the ruins of Clifford Castle; where tradition informs us the celebrated Rosamond spent her early life.

Soon after you arrive at the Hay, a town pleasantly seated on the Wye. It was formerly a Roman station, and was long afterwards considered as a place of great strength, being defended by a castle and lofty walls, till Owen Glendower laid it in ashes in one of those expeditions in which he drove Harry Bolingbroke

—*thrice from the banks of Wye,*
And sandy-bottomed Severn—

If you have time to make a little excursion, you will find, about half way between the Hay and Abergavenny, the ruins of Llanthony Priory. Dugdale describes it, in his *Monasticon*, as a scene richly adorned with wood. But Dugdale lived a century ago; which is a term that will produce or destroy the finest scenery. It has had the latter effect here, for the woods about Llanthony Priory are now totally destroyed; and the ruin is wholly naked and desolate.

After this excursion you return again to the Hay, and continue your route to Builth, still on the south side of the river.

On the north side, about four miles beyond the Hay, stands Maeslough, the ancient seat of the Howarths. The house shews the neglect of its possessor; though the situation is in its kind perhaps one of the finest in Wales. The view from the hall door is spoken of as wonderfully amusing. A lawn extends to the river, which encircles it with a curve, at the distance of half a mile. The banks are enriched with various objects; among which, two bridges, with winding roads, and the tower of Glasbury church, surrounded by a wood are conspicuous. A distant country equally enriched, fills the remote parts of the landscape, which is terminated by mountains. One of the bridges in this view, that at Glasbury, is remarkably light and elegant, consisting of several arches. —How these various objects are brought together I know not. I should fear there are too many of them.

As you continue your route to Builth, the country grows grander and more picturesque. The valley

of the Wye becomes contracted, and the road runs at the bottom, along the edge of the water.

It is possible, I think, the Wye may in this place be more beautiful than in any other part of its course. Between Ross and Chepstow, the grandeur and beauty of its *banks* are its chief praise. The *river itself* has no other merit than that of a winding surface of smooth water. But here, added to the same decoration from its banks, the Wye itself assumes a more beautiful character; pouring over shelving rocks, and forming itself into eddies and cascades, which a solemn parading stream through a flat channel cannot exhibit.

An additional merit also accrues to such a river from the different forms it assumes, according to the fullness or emptiness of the stream. There are rocks of all shapes and sizes, which continually vary the appearance of the water as it rushes over or plays among them; so that such a river, to a picturesque eye, is a continued fund of new entertainment.

The Wye also, in this part of its course, still receives farther beauty from the woods which adorn its banks, and which the navigation of the river, in its lower reaches, forbids. Here the whole is perfectly rural and unencumbered. Even a boat, I believe, is never seen beyond the Hay. The boat itself might be an ornament; but we should be sorry to exchange it for the beauties of such a river as will not suffer a boat.

Some beauties, however, the smooth river possesses above the rapid one. In the latter you cannot have those reflections which are so ornamental to the former: nor can you have in the rapid river the opportunity of contemplating the grandeur of its banks from the surface of the water, unless indeed the road winds close along the river at the bottom, when perhaps you may see them with additional advantage.

The foundation of these criticisms on *smooth* and *agitated* water is this: when water is exhibited in *small quantities* it wants the agitation of a torrent, a cascade, or some other adventitious circumstance to give it consequence; but when it is spread out in the *reach of some capital river*, in a *lake*, or an arm of the sea, it is then able to support its own dignity: in the former case it aims at beauty; in the latter at

grandeur. Now the Wye has in no part of its course a quantity of water sufficient to give it any great degree of grandeur; so that of consequence the *smooth* part must, on the whole, yield to the more *agitated*, which possesses more beauty.

In this wild enchanting country stands Llangoed, the house of Sir Edward Williams. It is adorned, like the house at Foxley, with woods and playing grounds; but is a scene totally different. Here, however, the trees are finer than those at Foxley; and, when examined as individuals, appear to great advantage; though my journalist has heard that some of the best of them have lately been cut down.

The road still continues through the same beautiful country along the banks of the Wye; and in a few miles farther brings you to Builth. This town is seated in a pleasant vale surrounded with woods.

A little beyond Builth, where the river Irvon falls into the Wye, is a field, where, tradition says, Llywelyn, the last prince of Wales, was put to death. Some historians say he was killed in battle; but the traditional account of his being killed near Builth seems more probable, and that he fell by the hands of an assassin. When Edward invaded Wales, Llywelyn had entrenched himself in the fastnesses of Snowdon. Here he might probably have foiled his adversary; but some of his troops having been successful against the Earl of Surrey, one of Edward's generals, Llywelyn came down from his strongholds, with the hope of improving his advantage, and offered Edward battle. Llywelyn was totally routed; and, in his flight into Glamorganshire, slept, the night before he was murdered, at Llechryd, which is now a farmhouse. Here the farrier who shod his horse knew him under his disguise, and betrayed him to the people of Builth, who put him to death; and are to this day stigmatized with the name of *Bradwyr y Buallt*, the *traitors of Builth*.

At Builth you cross the Wye again, and now pursue your route along the north side of the river. The same grand scenery continues, lofty banks, woody vales, a rocky channel, and a rapid stream.

Soon after you come to the sulphureous springs of Llandrindod, which you leave on the right; and

crossing the river Ithon, reach Rhayader, a town about thirteen miles beyond Builth. —To a Welshman the appearance of the Wye at Rhayader need not be described. The word signifies a *waterfall*. There is no cascade indeed of consequence near the place; but the river being pent up within close rocky banks, and the channel being steep, the whole is a succession of waterfalls.

As you leave Rhayader you begin to approach the sources of the Wye. But the river having not yet attained its chief supplies, is rather insignificant; and as the country becomes wilder and more mountainous, the scenery of the river is now *disproportioned*. There is not a sufficiency of water in the landscape to balance the land.

Llangurig, which is about twelve miles from Rhayader, is the last village you find on the banks of the Wye. Soon after all signs of inhabitancy cease. You begin to ascend the skirts of Plinlimmon; and after rising gradually about ten miles from Llangurig, you arrive at the sources of a river, which through a course of so many leagues hath afforded you so much entertainment.

It is a singular circumstance, that within a quarter of a mile of the well-head of the Wye, arises the Severn. The two springs are nearly alike; but the fortunes of rivers, like those of men, are owing to various little circumstances, of which they take the advantage in the early parts of their course. The Severn meeting with a tract of ground rising on the right, soon after it leaves Plinlimmon, receives a push towards the north-east. In this direction it continues its course to Shrewsbury. There, taking the advantage of other circumstances, it makes a turn to the south-east. Afterwards, still meeting with favourable opportunities, it successfully improves them; enlarging its circle; sweeping from one country to another; receiving large accessions everywhere of wealth and grandeur; till at length, with a full tide, it enters the ocean under the character of an arm of the sea. —In the meantime the Wye, meeting with no opportunities of any consequence to improve its fortunes, never makes any figure as a capital river, and at length becomes subservient to that very Severn, whose birth and early setting out in life were exactly similar to its own. —Between

these two rivers is comprehended a district, consisting of great part of the counties of Montgomery, Radnor, Shropshire, Worcester, Hereford, and Gloucester: of the last country only that beautiful portion which forms the Forest of Dean.

The country about Plinlimmon, vast, wild, and unfurnished, is neither adorned with accompaniments to be a scene of beauty: nor affords the materials of a scene of grandeur. —Though grandeur consists in simplicity, it must take *some form of landscape*; otherwise it is a shapeless waste; monstrous without proportion. —As there is nothing therefore in these inhospitable regions to detain you long, and no refreshment to be had, except a draught of pure water from the fountains of the Wye, you will soon be inclined to return to Rhayader.

From Rhayader my journal leads into Cardiganshire. Crossing the Wye you ascend a very steep mountain, about seven miles over. Then skirting the banks of a sweet little river, the Elan, which falls into the Wye, you pass through a corner of Montgomeryshire, which brings you to the verge of Cardiganshire.

The passage into this county is rather tremendous. You stand on very high ground, and see extending far below, a long contracted valley. The perspective from the top gives it rather the appearance of a chasm. Down one of the precipitous sides of this valley the road hurries you; while the river Ystwyth at the bottom is ready to receive you, if your foot should slip or your horse stumble.

Having descended safely into the bottom of the valley, and having passed through it, you cross the river over a handsome bridge, and arrive at the village of Pentre. Near this place is Hafod, the seat of Mr. Johnes, member for Radnorshire, which affords so much beautiful scenery that you should by no means pass by it. It will open suddenly upon you, at the close of a well-conducted approach. The house is new, built in a style between Gothic and Moorish. It is a style of building I am not acquainted with; but I am informed it has a good effect. It is a large commodious mansion, richly furnished. One thing is worth observing: over the chimney of the dining room is placed a neat tablet of white marble with this inscription:

——*Prout cuique libido est,*
Siccat inequales cyathos.——*

The Welsh gentry are remarkable for their hospitality; which sometimes, I have heard, will not allow the *inequales cyathos*†; but brings all to a *brimming level*. The spirit of this inscription, I hope, is diffusing itself more and more over the country.

But elegant houses and rich furniture are everywhere to be found. The scenery at Hafod is the object; and such scenery is rarely met with. —The walks are divided into what is called the *Ladies' walk*, a circuit of about three miles; and the *Gentlemen's walk*, about six. To these is added a more extensive round, which might properly come under the denomination of a *riding*, if in all parts it was accessible to horsemen.

The general ground-plot of these walks, and the scenery through which they convey you, are much beyond what we commonly meet with.

*Every man is at liberty to fill his glass to the height he chooses.
†Glasses unequally filled.

The river Ystwyth runs at the distance of about a quarter of a mile, from the house, which stands upon a lawn consisting of varied grounds descending to the river. It is a rapid stream, and its channel is filled with rocks, like many other Welsh streams, which form cataracts and cascades in various parts, more broken and convulsed than the Wye about Builth. Its banks consist of great variety of wooded recesses, hills, sides of mountains, and contracted valleys, thwarting and opposing each other in various forms; and adorned with little cascades running everywhere among them in guttered chasms. Of the grandeur and beauty of these scenes I can speak as an eye-witness: for though I was never on the spot, I have seen a large collection of drawings and sketches (not fewer than between twenty and thirty) which were taken from them.

Through this variety of grand scenery the several walks are conducted. The views shift rapidly from one to another; each being characterized by some circumstance peculiar to itself.

The artificial ornaments are such chiefly as are necessary. Many bridges are wanted, both in crossing

the Ystwyth and the several streams which run into it from the surrounding hills; and they are varied as much as that species of architecture will admit, from the stone arch to the Alpine plank. —In one place you see a cottage pleasantly seated among the thickets of a woody hill, which Mr. Johnes intends to fit up for the accommodation of a band of musicians; for so a pack of hounds may be called among the hills, and dales, and echoing rocks of these grand scenes.

Among the natural curiosities of the place is a noble cascade sixty feet high, which is seen through a cavern, partly natural and partly artificial. You enter it by a passage cut through a rock four feet broad and seven high; which continues about twenty yards, and brings you into a very lofty perforated cavern, through which you see the cascade to great advantage.

From the scenes of Hafod you continue your excursions, among some other grand and beautiful exhibitions of landscape.

You are carried first to the Devil's Bridge, about four miles from Hafod. I do not clearly understand the nature of the scenery here from the account given in my journal; but I should suppose it is only one grand piece of foreground, without any distance or accompaniments; and probably one of those scenes which is itself sufficient to form a picture. The plan of it is a rocky chasm, over which is thrown an arch. Between the cheeks of this chasm, and just beneath the bridge, the river Fynnach falls abruptly down the space of several yards; and afterwards meeting with other steeps, makes its way, after a few of these interruptions, into the Rheidol a little below. The bridge, I should suppose, is an interesting object. It consists of two arches, one thrown over the other; the under one, which is that said to be built by the devil, was not thought sufficiently strong. The common people suppose, when he built it he had some mischief in his head.

From the Devil's Bridge you visit Monk's Bridge; where the same kind of scenery is exhibited under a different modification.

From this place you descend into the vale of Rheidol, called so from the river of that name, which passes through it.

OBSERVATIONS ON THE RIVER WYE

If the Welsh counties, distinguished for so much beautiful scenery of various kinds, are remarkable for pre-eminence in any mode, I think it is in their *vales*. Their lakes are greatly exceeded, both in grandeur and beauty, by those of Cumberland, Westmorland, and Scotland. Nor are their mountains, as far as I have observed, of such picturesque form as many I have seen in those countries. They are often of a heavy lumpish kind; for there are orders of architecture in mountains as well as in palaces. Their rivers, I allow, are often very picturesque; and so are their sea-coast views. But their *vales* and *valleys*, I think, exceed those of any country I ever saw.

The vale of Rheidol is described as a very grand and extensive scene, continuing not less than ten miles, among rocks, hanging woods, and varied ground, which in some parts becomes mountainous; while the river is everywhere a beautiful object; and twice or three times, in its passage through the vale, is interrupted in its course, and formed into a cascade. This is a circumstance in a *vale*, I think, rather uncommon. In a *contracted valley* it is frequent; but an *extended vale*, as I apprehend this to be, is seldom so interrupted as not to give way to the river on one side or the other. I can easily however imagine, that when the *whole vale* is interrupted, as I conceive it to be here, it will occasion a very beautiful scene, if the eye, from so good a *foreground*, hath such an elevated station as will enable it to trace the winding of the vale at a distance beyond the cascade. But this is perhaps reasoning (as we often do on higher subjects) without sufficient grounds. On the spot I should probably find that all these conceptions are wrong, that the obstructions of the river in the vale of Rheidol are no advantage to the scene, or, perhaps, after all, that the *vale of Rheidol* does not deserve that name; but is only a *contracted valley* of considerable length.

At the end of this *vale* or *valley*, by whichsoever of these names it ought to be distinguished, stands the ruins of Aberystwyth Castle. Of this fortress little now remains but a solitary tower, overlooking the sea. Once it was the residence of the great Cadwallader; and in all the Welsh wars was considered as a fortress of the first consequence. Even so

late as the civil wars of the last century it was esteemed a place of strength.

But the rich lead mines in its neighbourhood were the basis of its glory. These mines are said to have yielded near a hundred ounces of silver from a ton of lead; and to have produced a profit of two thousand pounds a month. Here Sir Hugh Middleton made that vast fortune, which he expended afterwards on the New River. But a gentleman of the name of Bushel worked these mines to the most profitable extent. He was allowed by Charles the First the privilege of setting up a mint in this castle for the benefit of paying his workmen. Here therefore all the business of the mines was transacted, which made Aberystwyth Castle a place of more consequence and resort than any other place in Wales. King Charles also appointed Mr. Bushel governor of the Isle of Lundy; where he made a harbour for the security of his vessels, which carried the produce of his mines up the Severn. When the civil wars broke out, he had an opportunity of shewing his gratitude; which he did with the magnificence of a prince. He clothed the king's whole army, and offered his majesty a loan, which was considered as a gift, of forty thousand pounds. Afterwards, when Charles was pressed by the parliament, Mr. Bushel raised a regiment in his service at his own expense.

From the vale of Rheidol, you seek again the banks of the Ystwyth, and enter a vale which takes its name from the river.

This scene is another proof of what I have just observed of the Welsh vales. From the accounts I have heard of it, I should suppose it a scene of extraordinary beauty, *less romantic* than the vale of Rheidol, but *more* sylvan. Nature has introduced the rock more sparingly, but has made great amends by wood; though in one part of it, an immense rock forms a very grand feature. —It is much easier, however, to *conceive* the variety of these scenes than to describe them. Nature's alphabet consists only of four letters; wood, water, rock, and ground: and yet, with these four letters she forms such varied compositions, such infinite combinations, as no language with an alphabet of twenty-four can describe.

From the vale of Ystwyth you may visit the ruins of the abbey of Strata Florida: but there is little among those ruins, I should suppose, worth notice, except a Saxon gateway; and that can hardly be an object of much beauty. The painter, therefore, can make little use of this old abbey, and consigns it to the antiquarian, who tells you it was formerly the sacred repository of the bones of several of the Welsh princes; and that here the records and acts of the principality were preserved for many generations.

From the ruins of Strata Florida you return to Hereford, through Rhosfair, Rhayader, Penybont, and New Radnor; in which route I find nothing in my journal mentioned as worth notice; though it is hardly possible that in so large a tract of rough country there should not be many picturesque passages.

Here we drop our journal and return to Monmouth.

FROM Monmouth to Abergavenny, by Raglan Castle, the road is a good stone causeway (as the roads in these parts commonly are), and leads through a pleasant enclosed country, discovering on each side extensive views of rich cultivation.

Raglan Castle seemed to stand (as we saw it from the heights) in a vale; but as we descended, it took an elevated station. It is a large and very noble ruin: more perfect than ruins of this kind commonly are. It contains two areas within the ditch; into each of which you enter by a lofty and lengthened gateway.

The buildings which circumscribe the first area, consist of the kitchen and offices. It is amusing to hear stories of ancient hospitality. 'Here are the remains of an oven,' said our conductor, 'which was large enough to bake a whole ox; and of a fire-range wide enough to roast him.'

The great hall, or banqueting-room, a large and lofty apartment, forms the screen between the two areas; and is perfect, except the roof. The music

gallery may be distinctly traced; and the butteries, which divide the hall from a parlour. Near the hall is shewn a narrow chapel.

On viewing the comparative size of halls and chapels in old castles, one can hardly, at first, avoid observing, that the founders of these ancient structures supposed a much greater number of people would meet together, to feast than to pray. But yet we may perhaps account for the thing, without calling in question the piety of our ancestors. The hall was meant to regale a whole country; while the chapel was intended only for the private use of the inhabitants of the castle.

The whole area of the first enclosure is vaulted, and contains cellars, dungeons, and other subterraneous apartments. —The buildings of the second area are confined merely to chambers.

Near the castle stands the citadel, a large octagonal tower; two or three sides of which are still remaining. This tower is encircled by a separate moat: and was formerly joined to the castle by a drawbridge.

Raglan Castle owes its present picturesque form

to Cromwell, who laid his iron hands upon it; and shattered it into ruin. A window is shewn, through which a girl in the garrison, by waving a handkerchief, introduced his troops.

From Raglan Castle the views are still extensive, the roads enclosed, and the country rich.§ The distances are skirted by the Brecon Hills; among which the Sugar Loaf makes a remarkable appearance.

The Brecon Hills are little more than gentle swellings, cultivated to the top. For many miles they kept their station in a distant range on each side. But by degrees they began to close in, approximating more and more, and leaving in front a narrow pass between them; through which an extensive country appeared. Through this pass we hoped the progress of our road would lead us; as it seemed to open into a fair and beautiful country.

It led us first to Abergavenny, a small town, which has formerly been fortified, lying under the hills. We approached it by the castle; of which nothing remains but a few staring ruins.

§ This is where Gilpin placed Plate 12 (page 6 of this edition)

Hence we were carried, as we expected, through the pass; which we had long observed at a distance, and which opened into the vale of Usk.

The vale of Usk is a delightful scene. The river from which it borrows its name winds through the middle of it; and the hills, on both sides, are diversified with woods and lawns. In many places they are partially cultivated. We could distinguish little cottages and farms, faintly traced along their shadowy sides; which, at such a distance, rather varied and enriched the scene, than impressed it with any regular and unpleasing shapes.

Through this kind of road we passed many miles. The Usk continued everywhere our playful companion; and if at any time it made a more devious curve than usual, we were sure to meet it again at the next turn. Our passage through the vale was still more enlivened by many little foaming rills crossing the road (some of them large enough to make bridges necessary), and two ruined castles, with which, at proper intervals, the country is adorned.§

§ This is where Gilpin placed Plate 13 (page 5 of this edition)

After leaving the latter of them, called Tretower Castle, we mounted some high grounds, which gave variety to the scene, though not so picturesque an exhibition of it. Here the road brought us in view of Llangors Pool; which is no very inconsiderable lake. As we descended these heights, the Usk met us once more at the bottom, and conducted us into Brecon.

Brecon is a very romantic place, abounding with broken grounds, torrents, dismantled towers, and ruins of every kind. I have seen few places where a landscape painter might get a collection of better ideas. The castle has once been large; and is still a ruin of dignity. It is easy to trace the main body, the citadel, and all the parts of ancient fortification.

In many places indeed these works are too much ruined even for picturesque use. Yet, ruined as they are, as far as they go they are amusing. The arts of modern fortification are ill calculated for the purposes of landscape. The angular and formal works of Vauban and Coehoorn, when it comes to their turn to be superseded by works of superior invention, will make a poor figure in the annals of picturesque beauty. No eye will ever be delighted with

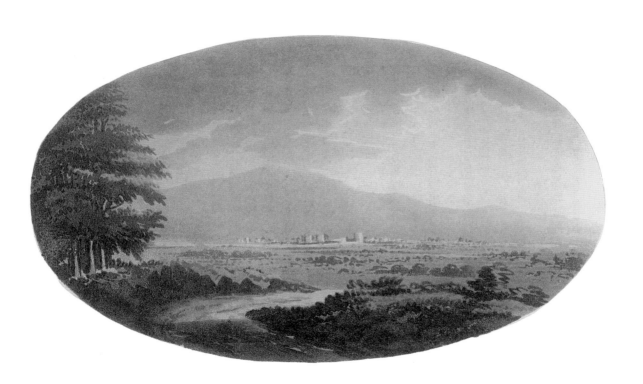

their ruins; while not the least fragment of a British or a Norman castle exists, that is not surveyed with delight.

But the most beautiful scenery we saw at Brecon, is about the abbey. We had a view of it, though but a transient view, from a little bridge in the neighbourhood. There we saw a sweet limpid stream, glistening over a bed of pebbles, and forming two or three cascades as it hurried to the bridge. It issued from a wood, with which its banks were beautifully hung. Amidst the gloom arose the ruins of the abbey, tinged with a bright ray, which discovered a profusion of rich Gothic workmanship; and exhibited in pleasing contrast the grey stone, of which the ruins are composed, with the feathering foliage that floated around them; but we had no time to examine how all these beauteous parts were formed into a whole. —The imagination formed it, after the vision vanished: but though the imagination might possibly create a *whole* more agreeable to the rules of painting, yet it could scarcely do justice to the beauty of the *parts*.

From Brecon, in our road to Trecastle, we enter a country very different from the vale of Usk. This too is a vale: but Nature always marks even kindred scenes with some peculiar character. The vale of Usk is almost one continued winding sweep. The road *now* played among a variety of hills. The whole seemed to consist of one great vale divided into a multiplicity of parts. All together, they wanted unity; but separately, afforded a number of those pleasing passages, which, treasured up in the memory, become the ingredients of future landscapes.

Sometimes the road, instead of winding round the hills, took the shortest way over them. In general, they are cultivated like those of the vale of Usk: but as the cultivation in many of them is brought too near the eye, it becomes rather offensive. Our best ideas were obtained from such as were adorned with wood; and fell, in various forms, into the valleys below.

In these scenes we lost the Usk, our sweet, amusing companion in the vale: but other rivers of the same kind frequently met us, though they seldom continued long; disappearing in haste, and hiding

themselves among the little tufted recesses at the bottom of the hills.

In general, the Welsh gentlemen in these parts seem fond of whitening their houses, which gives them a disagreeable glare. A *speck* of white is often beautiful; but white, in *profusion*, is, of all tints, the most in-harmonious. A white seat at the corner of a wood, or a few white cattle grazing in a meadow, enliven a scene perhaps more than if the seat or the cattle had been of any other colour. They have meaning and effect. But a front and two staring wings, an extent of rails, a huge Chinese bridge, the tower of a church, and a variety of other large objects, which we often see daubed over with white, make a disagreeable appearance, and unite ill with the general simplicity of Nature's colouring.

Nature never colours in this offensive way. Her surfaces are never white. The chalky cliff is the only permanent object of the kind which she allows to be hers; and this seems rather a force upon her from the boisterous action of a furious element. But even here it is her constant endeavour to correct the offensive tint. She hangs her chalky cliff with samphire and other marine plants; or she stains it with various hues, so as to remove, in part at least, the disgusting glare. The western end of the Isle of Wight, called the Needle Cliffs, is a remarkable instance of this. These rocks are of a substance nearly resembling chalk: but Nature has so reduced their unpleasant lustre by a variety of chastising tints, that in most lights they have even a beautiful effect. She is continually at work also, in the same manner, on the white cliffs of Dover; though her endeavours here are more counteracted by a greater exposure. But here, and in all other places, were it not for the intervention of foreign causes, she would in time throw her green mantle over every naked and exposed part of her surface.

In these remarks I mean only to insinuate, that *white* is a hue which nature seems studious to expunge from all her works, except in the touch of a flower, an animal, a cloud, a wave, or some other diminutive or transient object; and that *her mode* of colouring should always be the model of *ours*.

In animadverting however on *white objects*, I would only censure the mere *raw tint*. It may easily

be corrected, and turned into stone-colours of various hues; which though light, if not too light, may often have a good effect.

Mr. Lock, who did me the favour to overlook these papers, made some remarks on this part of my subject, which are so new and so excellent, that I cannot, without impropriety, take the credit of them myself.

White offers a more extended scale of light and shadow than any other colour, when near: and is more susceptible of the predominant tint of the air, when distant. The transparency of its shadows (which in near objects partake so little of darkness, that they are rather second lights) discovers, without injuring the principal light, all the details of surfaces.

I partake, however, of your general dislike to the colour; and though I have seen a very *splendid effect* from an *accidental light* on a white object, yet I think it a hue which oftener injures than improves the scene. It particularly disturbs the air in its office of graduating distances, shews objects nearer than they really are, and by pressing them on the eye, often gives them an importance, which from their form and situation they are not entitled to.

The white of snow is so active and refractory as to resist the discipline of every harmonizing principle. I think I never saw Mont Blanc, and the range of snows which run through Savoy, in union with the rest of the landscape, except when they were tinged by the rays of the rising and setting sun, or participated of some other tint of the surrounding sky. In the clear and colourless days so frequent in that country, the Glaciers are always out of tune.

SECTION VIII

FROM Trecastle we ascended a steep of three miles, which the country people call a *pitch*. It raised us to a level with the neighbouring hills, whose rugged summits interrupted our views into the valleys below.

From these heights we descended gently through a space of seven miles. As we approached the bottom, we saw at a distance the town of Llandovery, seated in the meadows below, at the conflux of several rivulets. Unadorned with wood, it made only a naked appearance; but light wreaths of smoke rising from it in several parts shewed that it was inhabited, while a ray of the setting sun singled it out among the objects of the vale, and gave it some little consequence in the landscape. As we descended into it, its importance increased. We were met by an old castle which had formerly defended it, though nothing remains except the ruins of the citadel.

Llandovery stands at the entrance of the vale of Towy, which, like other vales, receives its name from the river that winds through it; its delightful scenery opened before us as we left Llandovery in our way to Llandeilo, which stands about twelve miles lower in the vale.

The vale of Towy is still less a scene of cultivation that that of Usk; the woodland views are more frequent, and the whole more wild and simple. The scenery seems precisely of that kind with which a great master in landscape was formerly enamoured.

> ——*Juvat arva videre*
> *Non rastris hominum, non ulli obnoxia curæ:*
> *Rura mihi, & rigui placeant in vallibus amnes;*
> *Flumina amem, sylvasques*——*

In this vale the river Towy, though it frequently met us, and always kept near us, yet did not so constantly appear, and bear us such close company, as the Usk had done before. Some heights too we ascended, but such heights as were only proper stands, whence we viewed in greater perfection the beauties of the vale.

This is the scene which Dyer celebrated in his poem of *Grongar Hill*. Dyer was bred a painter; and had here a good picturesque subject; but he does not give us so good a landscape as might have been expected. We have nowhere a complete formed distance; though it is the great idea suggested by such a vale as this: nowhere any touches of that

* Countries which have never known the plough are my delight—wild woods and rivers wandering through artless vales.

beautiful obscurity which melts a variety of objects into one rich whole. Here and there we have a few *accidental* strokes which belong to distance,* though seldom masterly. I call them *accidental*, because they are not employed in producing a landscape; nor do they in fact unite in any such idea; but are rather introductory to some moral sentiment, which, however good in itself, is perhaps here rather forced and misplaced.

Dynevor Castle, which stands about a mile from Llandeilo, and the scenery around it, were the next objects of our curiosity. This castle is seated on one of the sides of the vale of Towy, where it occupies a bold eminence richly adorned with wood. It was used not long ago as a mansion; but Mr. Rice, the proprietor of it, has built a handsome house in his park, about a mile from the castle, which, however, he still preserves as one of the greatest ornaments of his place.

This castle also is taken notice of by Dyer in his *Grongar Hill*, and seems intended as an object in a distance; but *his* distances, I observed, are all in confusion; and indeed it is not easy to separate them from his foregrounds.

The landscape he gives us, in which the castle of Dynevor makes a part, is seen from the brow of a distant hill. The first object that meets his eye is a wood: it is just beneath him, and he easily distinguishes the several trees of which it is composed :

> *The gloomy pine, the poplar blue,*
> *The yellow beech, the sable yew,*
> *The slender fir that taper grows,*
> *The sturdy oak with broad-spread boughs.*

*As where he describes the beautiful form which removed cultivation takes:
> *How close and small the hedges lie!*
> *What streaks of meadow cross the eye!*
Or a distant spire seen by sunset:
> *Rising from the woods the spire*
> *Seems from far, ascending fire.*
Or the aerial view of a distant hill:
> *—yon summits soft and fair*
> *Clad in colours of the air;*
> *Which to those, who journey near,*
> *Barren, brown, and rough appear.*

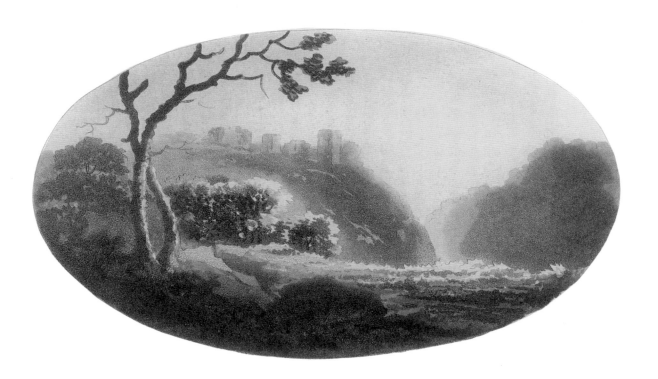

This is perfectly right; objects so near the eye should be distinctly marked. What next strikes him is a *purple grove*; that is, I presume, a grove which has gained its *purple hue* from distance. This is, no doubt, very just colouring; though it is here, I think, introduced rather too early in the landscape. The blue and purple tints belong chiefly to the most removed objects, which seem not here to be intended. Thus far, however, I should not greatly cavil.

The next object he surveys is a level lawn, from which a hill crowned with a castle arises; this is meant, I am informed, for Dynevor. Here his great want of *keeping* appears. The castle, instead of being marked with still fainter colours than the *purple grove*, is touched with all the strength of a foreground; you see the very ivy creeping upon its walls. Transgressions of this kind are common in descriptive poetry. Innumerable instances might be collected from better poems than *Grongar Hill*. But I mention only the inaccuracies of an author, who, as a painter, should at least have observed the most obvious principles of his art. —With how much more picturesque truth does Milton introduce a distant castle:

> *Towers and battlements he sees,*
> *Bosomed high in tufted trees.*

Here we have all the indistinct colouring which obscures a distant object. We do not see the iron-grated window, the portcullis, the ditch, or the rampart. We can just distinguish a castle from a tree, and a tower from a battlement.

The scenery around Dynevor Castle is very beautiful, consisting of a rich profusion of wood and lawn; but what particularly recommends it is the great variety of ground. I know few places where a painter might study the inequalities of a surface with more advantage.

Nothing gives so just an idea of the beautiful swellings of ground as those of water, where it has sufficient room to undulate and expand. In ground which is composed of refractory materials, you are presented often with harsh lines, angular insertions, and disagreeable abruptnesses. In water, whether in gentle or in agitated motion, all is easy; all is

softened into itself; and the hills and the valleys play into each other, in a variety of beautiful forms. In agitated water abruptnesses indeed there are; but yet they are such as, in some part or other, unite properly with the surface around them, and are, on the whole, perfectly harmonious. Now if the ocean in any of these swellings and agitations could be arrested and fixed, it would produce that pleasing variety which we admire in ground. Hence it is common to take images from water and apply them to land. We talk of a waving line, an undulating lawn, and a billowy surface; and give a stronger and more adequate idea by such imagery than plain language can easily present.

The woods which adorn these beautiful scenes about Dynevor Castle, and which form themselves into many pleasing groups, consist chiefly of the finest oak; some of them of large Spanish chesnuts. There are a few, and but a few, young plantations.

The picturesque scenes which this place affords are numerous. Wherever the castle appears, and it appears almost everywhere, a landscape purely picturesque is generally presented. The ground is so beautifully disposed, that it is almost impossible to have bad composition. At the same time, the opposite side of the vale often appears as a background, and makes a pleasing distance.

Somewhere among the woody scenes of Dynevor, Spenser hath conceived, with that splendour of imagination which brightens all his descriptions, the cave of Merlin to be seated. Whether there is any opening in the ground which favours the fiction, I find no account; the stanzas however are too much in place to be omitted.

> *To Maridunum, that is now, by change*
> *Of name, Cayr-Merdin called, they took their way;*
> *There the wise Merlin whilom wont, they say,*
> *To make his wonne low underneath the ground,*
> *In a deep delve, far from the view of day,*
> *That of no living wight he mote be found.*
> *When so he counselled, with his sprights encompast round.*

> *And if thou ever happen that same way*
> *To travel, go to see that dreadful place;*

It is a hideous, hollow, cave-like bay
Under a rock, that lies a little space
From the swift Barry, tumbling down apace,
Amongst the woody hills of Dynevor.
But dare thou not, I charge, in any case
To enter into that same baleful bower,
For fear the cruel fiends should the unwares devour.

But standing high aloft, low lay thine ear;
And there such ghastly noise of iron chains,
And brazen caudrons thou shalt rombling hear,
Which thousand sprights with long enduring pains
Do toss, that it will stun thy feeble brains.
And oftentimes great groans, and grievous stounds,
When too huge toil, and labour them constrains.
And oftentimes loud strokes, and ringing sounds
From under that deep rock most horribly rebounds.*

As we returned from Dynevor Castle, into the road, a noble scene opened before us. It is a distant view of a grand circular part of the vale of Towy (circular at least in appearance), surrounded by hills, one behind another; and forming a vast amphitheatre. Through this expanse (which is rich to profusion with all the objects of cultivation, melted together into one mass by distance) the Towy winds in various meanders. The eye cannot trace the whole serpentine course of the river; but sees it here and there in glittering spots, which gives the imagination a pleasing employment in making out the whole. The nearest hills partake of the richness of the vale; the distant hills which rise gently above the others, seem barren.

SECTION IX

FROM Dynevor Castle we set out across the country for Neath; a good turnpike road, we were assured, would lead us thither, but we were told much of the difficulty of passing *the mountain*, as they emphatically call a ridge of high ground which lay before us.

Though we had left the vale of Towy, the country continued to wear the same face of hill and dale

*Book III, Canto 3

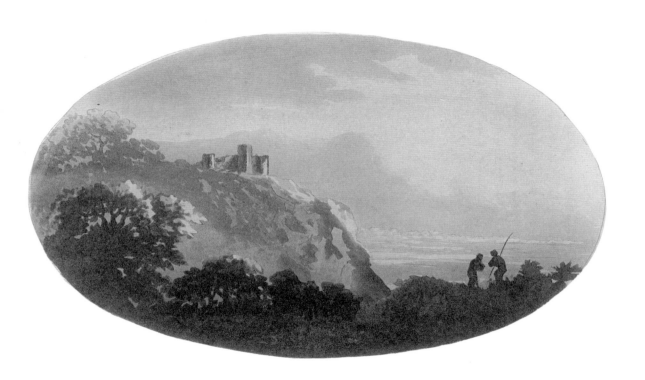

which it had so long worn. On the right we had still a distant view of the scenery of Dynevor Castle, which appeared like a grand woody bank. The woods also of Golden Grove varied the scene. Soon after, other castles, seated loftily on rising grounds, adorned other vales; Dryslwyn Castle on the right, and Carreg Cennen on the left.

But all these beautiful scenes by degrees were closed; castles, and winding rivers, and woody banks were left behind, one after another, and we approached nearer and nearer the tremendous mountain; which spread its dark mantle athwart the view.

It did not however approach precipitately; though it had long blotted out all distance, yet its environs afforded a present scene, and partook of the beautiful country we had passed. The ground about its foot was agreeably disposed, swelling into a variety of little knolls covered with oak, which a foaming rivulet, winding along, shaped into tufted islands and peninsulas of different forms, wearing away the soil in some parts from the roots of the trees, and in others delving deep channels; while the mountain afforded a dark solemn background to the whole.

At length we began to ascend; but before we had risen too high, we turned round to take a retrospect of all the rich scenes together, which we had left behind. It was a noble view, distance melting into distance, till the whole was closed by a semicircle of azure mountains, scarcely distinguishable from the sky which absorbed them.

Still ascending the spiral road round the shaggy side of the mountain, we arrived at what is called its *gate*. Here all idea of cultivation ceased. That was not deplorable; but with it our turnpike road ceased also; which was finished on this side, no farther than the *mountain gate*. We had gotten a guide however to conduct us over the pathless desert. But it being too steep and rugged to ascend on wheels, we were obliged to lighten our carriage, and ascend on foot.

In the midst of our labour, our guide called out that he saw a storm coming on along the tops of the mountains, a circumstance indeed which in these hilly countries cannot often be avoided. We

asked him, How far it was off? He answered, Ten minutes. In less time, sky, mountains, and valleys were all wrapt in one cloud of driving rain and obscurity.

Our recompence consisted in following with our eye the rear of the storm; observing through its broken skirts a thousand beautiful effects and half-formed images, which were continually opening, lost, and varying, till the sun breaking out, the whole resplendent landscape appeared again with double radiance, under the leaden gloom of the retiring tempest.

When we arrived at the top of the mountain, we found a level plain, which continued at least two miles. It was a noble terrace; but was too widely spread to give us a display of much distant scenery.

At length we began to descend the mountain, and soon met an excellent turnpike road, down which we slid swiftly, in an elegant spiral, and found, when we came to the bottom, that we had spent near four hours in surmounting this great obstruction.

Having thus passed the Mount Cenis of this country, we fell into the same kind of beautiful scenery on this side of it which we had left on the other: only here the scene was continually shifting, as if by magical interposition.

We were first presented with a view of a deep woody glen lying below us, which the eye could not penetrate, resting only on the tops and tuftings of the trees.

This suddenly vanished, and a grand rocky bank arose in front, richly adorned with wood.

It was instantly gone, as we were shut up in a close woody lane.

In a moment, the lane opened on the right, and we had a view of an enchanting vale.

We caught its beauties as a vision only. In an instant they fled, and in their room arose two bold woody promontories. We could just discover between them, as they floated past, a creek, or the mouth of a river, or a channel of the sea. We knew not what it was: but it seemed divided by a stretch of land of dingy hue, which appeared like a sand-bank.

WILLIAM GILPIN

This scene shifting, immediately arose, on our left, a vast hill, covered with wood; through which, here and there, projected huge masses of rock.

In a few moments it vanished, and a grove of trees suddenly shot up in its room.

But before we could even discover of what species they were, the rocky hill, which had just appeared on the left, winding rapidly round, presented itself full in front. It had now acquired a more tremendous form. The wood, which had before hid its terrors, was now gone; and the rocks were all left, in their native wildness, everywhere bursting from the soil.

Many of the objects which had floated so rapidly past us, if we could have examined them, would have given us sublime and beautiful hints in landscape; some of them seemed even well combined, and ready prepared for the pencil; but, in so quick a succession, one blotted out another; and it would have been endless to stop our chaise and examine them all. The country at length giving way on both sides, a view opened, which suffered the eye to rest upon it.

The river Neath, covered with shipping, was spread before us. Its banks were enriched with wood, amidst which arose the ruins of Neath Abbey, with its double tower. Beyond the river the country arose in hills, which were happily adorned, when we saw them in a clear serene evening, with one or two of those distant forges or charcoal-pits, which we admired on the banks of the Wye, wreathing a light veil of smoke along their summits and blending them with the sky. —Through this landscape we entered the town of Neath, which with its old castle, and bridges, excited many picturesque ideas.

SECTION X

As we left Neath, a grand vista of woody mountains, pursuing each other along the river, and forming, no doubt, some enchanting vale, if we had had time to examine it, stretched into remote distance.

The vistas of art are tame and formal. They consist of streets, with the unvarying repetition of

78

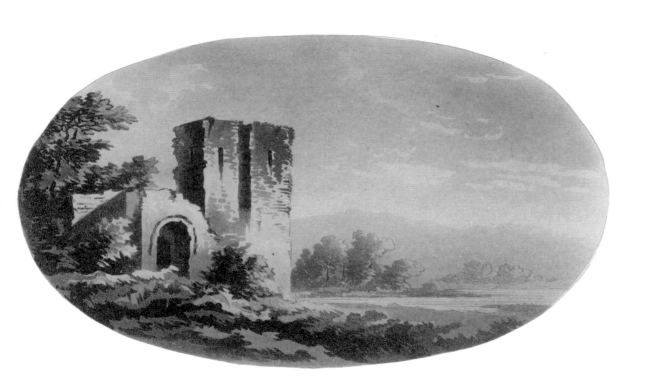

doors and windows; or they consist of trees planted nicely in rows; a succession of mere vegetable columns; or they consist of some other species of regularity: but Nature's vistas are of a different cast. She forms them sometimes of mountains, sometimes of rocks, and sometimes of woods. But all her works, even of this formal kind are the works of a master. If the idea of regularity be impressed on the *general form*, the *parts* are broken with a thousand varieties. Her vistas are models to paint from. —In *this* before us, both the mountains themselves and the perspective combination of them, were beautiful.

The broken ground about a copper-work, a little beyond the town, would afford hints for a noble landscape. Two contiguous hills appear as if riven asunder, and lay open a picturesque scene of rocky fragments, interspersed with wood, through which a torrent, forcing its way, forms two or three cascades before it reached the bottom.

A little beyond this, the views which had entertained us as we entered Neath, entertained us a second time as we left it. The river covered with shipping, presented itself again. The woody scenery arose on its banks, and the abbey appeared among the woods, though in different perspective, and in a more removed situation.

Here too we were again presented with those two woody promontories of which we had just obtained a glimpse before, with a creek or channel between them, divided by what seemed a sand-bank. We had now approached much nearer, and found we had been right in our conjecture*. The extensive object we had seen, was the bank of Margam, which, when the sea retires, is a vast sandy flat.

Hence we had, for a considerable time, continued views on the left of grand woody promontories pursuing each other, all rich to profusion, with sea views on the right. Such an intermixture of highlands and sea, where the objects are beautiful and well disposed, makes, in general, a pleasing mode of composition. The roughness of the mountains above, and the smooth expanse of the waters below,

* See p. 77

wonderfully aid each other by the force of contrast.

From these views we were hurried at once upon a bleak sea-coast, which gave a kind of relief to the eye, almost surfeited with rich landscape. Margam sand-bank, which, seen partially, afforded a sweet chastising tint to the verdure of the woody promontories through which we had twice seen it, became now (when unsupported and spread abroad in all its extension) a cold, disgusting object. —But relief was everywhere at hand, and we seldom saw it long without some intervention of woody scenery.

As we approached the river Avon, the country degenerated still more. Margam sand-bank, which was now only the boundary of marshes, became offensive to the eye; and though on the left the woody hills continued still shooting after us, yet they had lost their pleasing shapes. No variety of breaks, like the members of architecture, gave a lightness and elegance to their forms: no mantling furniture invested their sides; nor tufted fringe adorned their promontories; nor scattered oak discovered the sky through interstices along their towering summits: instead of this, they had degenerated into mere

uniform lumps of matter, and were everywhere overspread with one heavy uninterrupted bush.

Of this kind were Lord Mansell's woods which cover a promontory. Time with its lenient hand may hereafter hang new beauties upon these hills, when it has corrected their heaviness, by improving the luxuriance of youthful foliage into the lighter forms of aged trees.

From Lord Mansell's to Pyle, which stands on a bleak coast, the spirit of the country is totally lost.

Here we found the people employed in sending provisions to the shore, where a Dutch West-India ship had just been wrecked. Fifteen lives were lost, and among them the whole family of a Zealand merchant, who was bringing his children for education to Amsterdam. The populace came down in large bodies to pillage the wreck, which the officers of the customs and gentlemen of the country assembled to protect. It was a busy scene, composed of multitudes of men, carts, horses, and horsemen.

The bustle of a crowd is not ill-adapted to the pencil; but the management of it requires great

artifice. The whole must be massed together and considered as one body.

I mean not to have the whole body so agglomerated as to consist of no detached groups; but to have these groups (of which there should not be more than two or three) appear to belong to one whole, by the artifice of composition, and the effect of light.

This great whole must be varied also in its parts. It is not enough to stick bodies and heads together. Figures must be contrasted with figures, and life, spirit, and action must pervade the whole.

Thus in managing a crowd, and in managing a landscape, the same general rules are to be observed. Though the *parts* must be *contrasted*, the *whole* must be *combined*; but the difficulty is the greater in a crowd; as its parts, consisting of animated bodies, require a nicer observation of form: being all similar likewise, they require more art in the combination of them.

Composition indeed has never a more difficult work, than when it is engaged in combining a crowd. When a number of people, all coloured alike, are to be drawn up in rank and file, it is not in the art of man to combine them in a picturesque manner. We can introduce a rencounter of horse where all regularity is broken, or we can exhibit a few general officers with their aides-de-camp on the foreground, and cover a fighting army with smoke at a distance; but the files of war, the regiment or squadron in military array, admit no picturesque composition. Modern heroes, therefore, must not look to have their achievements recorded on canvas, till they abrogate their formal arts. —But even when we take all the advantages of shape and colour with which the human form can be varied or clothed, we find it still a matter of difficulty enough.

I do not immediately recollect having seen a crowd better managed than Hogarth has managed one in the last print of his idle apprentice. In combining the multifarious company, which attends the spectacle of an execution, he hath exemplified all the observations I have made. I have not the print before me; but I have often admired it in this light; nor do I recollect observing anything offensive in it;

which is rare in the management of such a multi-tude of figures.

The subject before us is as well adapted, as any species of crowd can be, to exhibit the beauties of composition. Horses, carts, and men make a good assemblage, and this variety in the parts would appear to great advantage in contrast with the sim-plicity of a winding shore, and or a stranded ship (a large dark object) heeling on one side, in the corner of the piece.

SECTION XI

FROM Pyle the country grows still worse; till at last it degenerates into a naked heath; and continues a long time totally unadorned, or at best with a few transient beauties.

At Bridgend, where we met the river Ogmore, a beautiful landscape bursts again upon us. Woody banks arise on both sides, on the right especially, which continue a considerable way, marking the course of the river. On the left is a rich distance.

Hence we pass in view of cultivated valleys, into which the rich distance we had just seen began to form itself, while the road winds over a kind of ter-race above them. An old castle also enriches the scene; till at length the terrace giving way, we sink into the vale, and enter Cowbridge.

The heights beyond Cowbridge give us the first view of the Bristol Channel on the right. The coun-try between the eye and the water has a marshy appearance, but being well blended, and the lines broken, it makes a tolerable distance. The road passes through pleasant enclosed lanes.

At the fifth stone before we reached Cardiff, we had a most grand and extensive view from the heights of St Lythans. It contained an immense stretch of country, melting gradually into a faint blue semi-circle of mountains, which edged the horizon; this scene indeed, painted in syllables, words, and sentences, appears very like some of the scenes we had met with before, but in nature it was very different from any of them.

In distant views of cultivated countries, seen from lofty stands, the parts which lie nearest the eye

are commonly disgusting. The divisions of property into squares, rhomboids, and other mathematical forms, are unpleasant. A view of this kind therefore does not assume its beauty, till on descending a little lower, the hedgerows begin to lengthen, and form those agreeable *discriminations* of which Virgil* takes notice; where fields and meadows become extended streaks, and yet are broken in various parts by rising grounds, castles, and other objects with which distances abound; melting away from the eye in one general azure tint, just here and there diversified with a few lines of light and shade, and dotted with a few indistinct objects. Then, if we are so happy as to find a ruin, a spreading tree, a bold rock, or some other object large enough, with its appendages, to become a foreground, and balance the distance (such as we found among the abrupt heights of Cotswold)†, we have the chance of being presented with a noble picture, which *distance alone* cannot give.

* —*et late discriminat agros.* Æneid, II 144.
† See p. 21

Hence appears the absurdity of carrying a painter to the top of a high hill to take a view. He cannot do it. Extension alone, though amusing in nature, will never make a picture. It *must* be *supported*.

Cardiff lies low, though it is not unpleasantly seated on the land side among woody hills. As we *approached*, it appeared with more of the furniture of antiquity about it than any town we had seen in Wales; but *on the spot* the picturesque eye finds it too entire to be in full perfection. The castle, which was formerly the prison of the unfortunate Robert, son of William the First, who languished here the last twenty years of his life, is still, I believe, a prison, and in good repair.

From the town and parts adjacent, the windings and approach of the river Taff from the sea, with the full tide, make a grand appearance. This is, on the whole, the finest estuary we have seen in Wales.

From the heights beyond Cardiff, the views of the channel on the right continue, and of the Welsh mountains on the left. The Sugar Loaf near

Abergavenny appears still distinctly. The road leads through enclosed lanes.

Newport lies pleasantly on a declivity. A good view might be taken from the retrospect of the river, the bridge and the castle. A few slight alterations would make it picturesque.

Beyond Newport some of the views of the Channel were finer than any we had seen. The coast, though it continues flat, becomes more woody, and the parts are larger.

About seven miles from Newport, the road winds among woody hills; which here and there form beautiful dips at their intersections. On one of these knolls stand the ruins of a castle, which has once made a grand appearance; but it is now degraded into a modern dwelling.

As we approached the passage over the Bristol Channel, the views of it became still more interesting. On the right, we left the magnificent ruins of Caldicot Castle, and arrived at the ferry-house about three in the afternoon, where we were so fortunate as to find the boat preparing to set sail. It had attempted to cross at high water in the morning, but after toiling three hours against the wind, it was obliged to put back. This afforded another opportunity when the water was at ebb; for the boat can pass only at the two extremes of the tide, and seldom oftener than once in a day.

We had scarcely alighted at the ferry-house, when we heard the boatman winding his horn from the beach about a quarter of a mile below, as a signal to bring down the horses. When they were all embarked, the horn sounded again for the passengers. A very multifarious company assembled; and a miserable walk we had to the boat through sludge and over shelving and slippery rocks. When we got to it we found eleven horses on board, and above thirty people; and our chaise (which we had intended to convert into a cabin during the voyage) slung into the shrouds.

The boat, after some struggling with the shelves, at length gained the Channel. The wind was unfavourable, which obliged us to make several *tacks*, as the seamen phrase them. These tacks occasioned a fluttering in the sail; and this produced a

fermentation among the horses, till their fears reduced them again to order.

Livy gives us a beautiful picture of the terror of cattle in a scene of this kind.—

Primus erat pavor, cum soluta rate, in altum raperentur. Ibi urgentes inter se, cedentibus extremis ab aquâ, trepidationem aliquantam edebant; donec quietem ipse timor circumspicientibus aquam fecisset.'*

The scenery of this short voyage was of little value. We had not here the steep folding banks of the Wye to produce a succession of new landscapes. Our picture now was motionless. From the beginning to the end of the voyage it continued the same: it was only a display of water, varied by that little change introduced by distance, on a coast which, seen from so low a point as the surface of the water,

*At first, when the vessel pushing from the shore, appeared surrounded by water, all was terror. The trembling animals urging each other on both sides from it, occasioned at first some confusion; but their fears subsiding gradually from the familiarity of the object, tranquillity took place. Bk XXI, cap. xxviii

became a mere thread. The screens bore no proportion to the area.

After beating near two hours against the wind, our voyage concluded as it began, with an uncomfortable walk through the sludge to the high-water mark.

The worst part of the affair is the usage of horses. If they are unruly, or any accident occurs, there is hardly a possibility, at least if the vessel be crowded, of affording them relief. Early in our voyage, as the boat heeled, one of the poor animals fell down. Many an ineffectual struggle it made to rise, but nothing could be done till we arrived at the other side.

The operation too of landing horses, is equally disagreeable. They are forced out of the boat, through an aperture in the side of it; which is so inconvenient a mode of egress, that in leaping many have been hurt from the difficulty of disengaging their hinder legs.

This passage as well as the other over the Severn (for there is one also a little above), are often esteemed dangerous. The tides are uncommonly

rapid in this channel; and when a brisk wind happens to blow in a contrary direction, the waters are rough. The boats too are often ill-managed; for what is done repeatedly, is often done carelessly. A British admiral, who had lived much at sea, riding up to one of these ferries, with an intention to pass over, and observing the boat, as she was working across the channel from the other side, declared he durst not trust himself to the seamanship of such fellows as managed her; and turning his horse, went round by Gloucester.

Several melancholy accidents indeed within the course of a dozen years, have thrown discredit on these ferries. One we had from a gentleman, who himself providentially escaped being lost. He went to the beach just as the vessel was unmooring. His horse had been embarked before, together with sixty head of cattle. A passage with such company appeared so disagreeable, that he and about six or seven passengers whom he found on the beach, among whom was a young lady, agreed to get into an open boat and be towed over by the large one.

The passage was rough, and they observed the cattle on board the larger vessel rather troublesome. They were now about half way over, when an ox near the aperture in the side of the vessel, mentioned above for the entrance and egress of cattle, entangled his horn in a wooden slider which closes it, and which happened according to the careless custom of boatmen, to be unpinned. The beast finding his head fixed, and endeavouring to disengage himself, drew up the slider. The vessel heeled; the tide rushed in; and all was instant confusion. The danger and the impossibility of opposing it in such a crowd struck every one at once.

In the meantime the passengers in the open boat, who were equally conscious of the ruin, had nothing left but to cut the rope, which tied them to the sinking vessel. But not a knife could be found in the whole company. After much confusion, a little neat tortoise-shell pen-knife was produced; with which unequal instrument they just got the rope severed, when the large vessel and its whole contents went down: all on board perished, except two or three oxen which were seen floating on the surface; and it was believed got to shore.

The joy of the passengers in the boat was however short-lived. It soon appeared they had escaped only one mode of death: they were left to themselves in a wide expanse of water; at the mercy of a tide ebbing with a violent current to the sea; without oars or sail; and without one person on board who had ever handled either. A gentleman among them had just authority enough to keep them all quiet; without which their safety could not have been ensured a moment. He then took up a paddle, the only instrument on board, with an intention, if possible, to get the boat on shore; but the young lady, who was his niece, throwing her arms round him in an agony of despair, not knowing what she did, would not let him proceed. He was obliged to quiet her by threatening in a furious tone to strike her down instantly with the oar, if she did not desist. Notwithstanding all his efforts they were hurried away by the ebbing waters as far as Kingroad; where the violence of the tide slackening, he prevented the boat from going out to sea; and got it by degrees to shore.

From the gentleman who told us this story, we had the account of the loss of an open boat in the same passage, through the obstinacy of a passenger.

The wind was rough, and a person on board lost his hat; which floated away in a contrary direction. He begged the waterman to turn round to recover it; but the waterman told him it was as much as their lives were worth to attempt it; on which the passenger, who seemed to be a tradesman, started up, seized the helm, and swore the fellow should return. In the struggle the helm got a wrong twist, and the boat instantly filled and went to the bottom. It appeared afterwards that the hat was of value, for the owner had secreted several bills in the lining of it.

For ourselves, however, we found the passage only a disagreeable one; and if there was any danger, we saw it not. The danger chiefly, I suppose, arises from carelessness and overloading the boat.

As our chaise could not be landed till the tide flowed up the beach, we were obliged to wait at the ferry-house. Our windows overlooked the channel, and the Welsh coast, which, seen from a higher stand, became now, a woody and beautiful distance. The wind was brisk and the sun clear, except that at

intervals it was intercepted by a few floating clouds. The playing lights, which arose from this circumstance on the opposite coast, were very picturesque. Pursuing each other, they sometimes just caught the tufted tops of trees; then gleaming behind shadowy woods, they spread along the vales till they faded insensibly away.

Often these partial lights are more stationary; when the clouds, which fling their lengthened shadows on distant grounds, hang some time balanced in the air. But whenever found, or from whatever source derived, the painter observes them with the greatest accuracy; he marks their different appearances, and lays them up in his memory among the choice ingredients of distant landscape. Almost alone they are sufficient to vary distance. A *multiplicity of objects*, melted harmoniously together, contribute to *enrich* it: but without throwing in these *gleaming lights*, the artist can hardly avoid *heaviness*.*

'When the shadows of floating clouds fall upon the sides of mountains, they have a bad effect. — See *Picturesque Observations on Scotch Landscape*, vol. ii. p. 152

FROM the ferry-house to Bristol, the views are amusing. The first scene was a spacious lawn, about a mile in diameter, the area of which was flat; and the boundary a grand woody bank, adorned with towers and villas, standing either boldly near the top, or seated in woody recesses near the bottom. The horizon line is well varied, and broken.

The whole of this landscape is too large; and not characterised enough to make a picture; but the contrast between the plain and the wood, both of which are objects of equal grandeur, is pleasing; and many of the parts, taken separately, would form into good composition.

When we left the plain, the road carried us into shady lanes, winding round woody eminences; one of which was crowned with an artificial castle. The castle indeed, which consisted of one tower, might have been better imagined: the effect however was good, though the object was paltry.

About three miles on this side of Bristol we had

a grand view of rising country. It consisted of a pleasing mixture of wood and lawn: the parts were large; and the houses and villages scattered in good proportion. The whole, when we saw it, was overspread with a purplish tint, which as the objects were so near, we could not account for; but it united all the parts together in very pleasing harmony.

Nature's landscapes are generally harmonized. Whether the sky is enlightened, or whether it lowers; whether it is tinted, or whether it is untinted, it gives its yellow lustre, or its grey obscurity, to the surface of the earth. It is but seldom however, that we meet with those *strong harmonizing tints*, which the landscape before us presented.

As the air is the vehicle of these tints, distant objects will of course participate of them in the greatest degree; the foregrounds will be little affected, as they are seen only through a very thin veil of tinted air. But when the painter thinks it proper to introduce these strong tints into his distances, he will give his foregrounds likewise, in some degree, a participating hue; more perhaps than in reality belongs to them; or, at least he will work them up

with such colours, mute or vivid, as accord best with the general tone of his landscape. —How far it is proper for him to attempt these uncommon appearances of nature, is not a decided question. If the landscape before us should be painted with that full purple glow, with which we saw it overspread, the connoisseur would probably take offence, and call it affected.

The approach to Bristol is grand; and the environs everywhere shew the neighbourhood of an opulent city; though the city itself lay concealed till we entered it. For a considerable way, the road led between stone walls, which bounded the fields on each side. This boundary, though of all others the most unpleasing, is yet not an improper approach to a great town; it is a kind of connecting thread.

The narrowness of the port of Bristol which is formed by the banks of the river, is very striking. It may be called a dry harbour, notwithstanding the river: for the vessels, when the tide ebbs, lie on an oozy bed in a deep channel. The returning tide lifts them to the height of the wharfs. It exhibits of

course none of those beautiful winding shores, which often adorn an estuary. The port of Bristol was probably first formed when vessels, afraid of being cut from their harbours by corsairs, ran up high into the country for security.

The great church is a remnant only of the ancient fabric. It has been a noble pile when the nave was complete, and the stunted tower crowned with a spire, as I suppose it once was. We were sorry we did not look into Radcliffe church, which is said to be an elegant piece of Gothic architecture.

The country around Bristol is beautiful, though we had not time to examine it. The scenery about the Hot Wells is in a great degree picturesque. The river is cooped between two high hills; both of which are adorned with a rich profusion of rock, wood, and verdure. Here is no offskip indeed, but as far as *foregrounds* alone make a picture (and they will do much better alone than *distances*), we are presented with a very beautiful one. —Between these hills stands the pump-room, close to the river; and every ship, that sails into Bristol, sails under its windows.

The road between Bristol and Bath contains very little worth notice. We had been informed of some grand retrospect views, but we did not find them. We were told afterwards, there are two roads between Bath and Bristol; of which the Gloucestershire road is the more picturesque. If so, we unfortunately took the wrong one.

At Bath the buildings are splendid; but the picturesque eye finds little amusement among such objects. The circus, from a corner of one of the streets that run into it, is thrown into perspective: and if it be happily enlightened, is seen with advantage. The crescent is built in a simpler, and greater style of architecture.

I have heard an ingenious friend, Colonel Mitford, who is well versed in the theory of the picturesque, speak of a very beautiful and grand effect of light and shade, which he had sometimes observed from an afternoon sun, in a bright winter day, on this structure. No such effect could happen in summer; as the sun, in the same meridian, would be then too high. A grand mass of light, falling on one side of the Crescent, melted imperceptibly into

as grand a body of shade on the other; and the effect rose from the *opposition* and *graduation* of these extremes. It was still increased by the pillars, and other members of architecture, which beautifully varied, and broke both the light and the shade, and gave a richness to each. The whole seemed like an effort of nature to set off art; and the eye roved about in astonishment to see a mere mass of regularity become the ground of so pleasing a display of harmony and picturesque effect. The elliptical form of the building was the magical source of this exhibition.

As objects of curiosity, the parades, the baths, the rooms, and the abbey, are all worth seeing. The rising grounds about Bath, as they appear from the town, are a great ornament to *it*: though they have nothing pleasing in *themselves*. There is no variety in the outline; no breaks, no masses of woody scenery.

From Bath to Chippenham, the road is pleasant: but I know not that it deserves any higher epithet.

From Chippenham to Marlborough, we passed over a wild plain, which conveys no idea but that of vastness, unadorned with beauty.

Nature, in scenes like these, seems only to have chalked out her designs. The ground is laid in, but left unfinished. The ornamental part is wanting — the river, or the lake winding through the bottom, which lies in form to receive it; the hanging rocks, to adorn some shooting promontory; and the woody screens to encompass, and give richness to the whole.

Marlborough Down is one of those vast dreary scenes, which our ancestors, in the dignity of a state of nature, chose as a repository of their dead. Everywhere we see the tumuli, which were raised over their ashes; among which the largest is Silbury Hill. These structures have no date in the history of time; and will be, in all probability, among its most lasting monuments. Our ancestors had no ingenious arts to gratify their ambition; and as they could not aim at immortality by a bust, a statue, or a piece of bas-relief, they endeavoured to obtain it by works of enormous labour. It was thus in other barbarous

countries. Before the introduction of arts in Egypt, kings endeavoured to immortalize themselves by lying under pyramids.

As we passed what are called the ruins of Avebury, we could not but admire the industry and sagacity of those antiquarians, who can trace a regular plan in such a mass of apparent confusion.*

At the great inn at Marlborough, formerly a mansion of the Somerset family, one of these tumuli stands in the garden, and is whimsically cut into a spiral walk; which, ascending imperceptibly, is lengthened into half a mile. The conceit at least gives an idea of the bulk of these massy fabrics.

From Marlborough the road takes a more agreeable appearance. Savernake Forest, through which it passes, is a pleasant woody scene: and great part of the way afterwards is adorned with little groves, and opening glades, which form a variety of second

*See an account of Avebury by Dr. Stukely

distances on the right. But we seldom found a foreground to set them off to advantage.

The country soon degenerates into open cornlands: but near Hungerford, which is not an unpleasant town, it recovers a little spirit; and the road passes through close lanes, with breaks here and there, into the country, between the boles of trees.

As we approach Newbury, we had a view of Donnington Castle, one of those scenes where the unfortunate Charles reaped some glory. Nothing now remains of this gallant fortress but a gateway and two towers. The hill on which it stands is so overgrown with brushwood, that we could scarcely discern any vestiges either of the walls of the castle, or of the works which had been thrown up against it.

This whole woody hill, and the ruins upon it, are now tenanted, as we were informed by our guide, only by ghosts; which however add much to the dignity of these forsaken habitations, and are, for that reason, of great use in description.

WILLIAM GILPIN

In Virgil's days, when the Tarpeian rock was graced by the grandeur of the capital, it was sufficiently ennobled. But in its early state, when it was *sylvestribus horrida dumis*, it wanted something to give it splendour. The poet therefore, has judiciously added a few ideas of the awful kind; and has contrived by this machinery to impress it with more dignity in its rude state, than it possessed in its adorned one:

Jam turn religio pavidos terrebat agrestes
Dira loci; jam tum sylvam, saxumque timebant.
'Hoc nemus, hunc,' inquit, 'frondoso vertice collem,
(Quis Deus, incertum est) habitat Deus. Arcades ipsum
Credunt se vidisse Jovem, cum sæpe nigrantem
Ægida concuteret dextrâ, nimbosque cieret. **

*Even then the awful genius of the place held the trembling rustic in awe. Even then he entered those gloomy woods, with superstitious fear. 'Some God, no doubt, (though what God is uncertain,) inhabits those sacred groves. The Arcadians often think they see Jove himself, flashing lightning from the clouds, when the louring storm comes forward over the lofty woods. Book III, Cant. 3

94

Of these imaginary beings the painter, in the meantime, makes little use. The introduction of them, instead of raising, would depreciate his subject. The characters indeed of Jupiter, Juno, and all that progeny, are rendered as familiar to us, through the antique, as those of Alexander and Cæsar. But the judicious artist will be cautious how he goes farther. The *poet* will introduce a phantom of any kind without scruple. He knows his advantage. He speaks to the *imagination*; and if he deals only in general ideas, as all good poets on such subjects will do, every reader will form the phantom according to his *own* conception. But the *painter*, who speaks to the *eye*, has a more difficult work. He cannot deal in *general* terms: he is *obliged* to *particularize*: and it is not likely, that the spectator will have the same idea of a phantom which he has. —The painter therefore acts prudently in abstaining, as much as possible, from the representation of fictitious beings.

The country about Newbury furnished little amusement. But if it is not *picturesque*, it is very *historical*.

In every *historical country* there are a set of ideas which peculiarly belong to it. Hastings, and Tewkesbury; Runnymede, and Clarendon, have all their associate ideas. The ruins of abbeys and castles have another set: and it is a soothing amusement in travelling, to *assimilate* the mind to the *ideas* of the *country*. The ground we now trod, has many historical ideas associated with it; two great battles, a long siege, and the death of the gallant Lord Falkland.

The road from Newbury to Reading, lead through lanes, from which a flat and woody country is exhibited on the right, and rising grounds on the left. Some unpleasant common fields intervene.

In the new road from Reading to Henley, the high grounds overlook a very picturesque distance on the right. The country indeed is flat; but this is a circumstance we do not dislike in a distance, when it contains a variety of wood and plain; and when the parts are large, and well-combined.

Henley lies pleasantly among woody hills: but the chalk, bursting everywhere from the soil, strikes the eye in spots; and injures the landscape.

Hence we struck again into the road across Hounslow Heath; having crowded much more within the space of a fortnight (to which our time was limited) than we ought to have done.

THE END

First published 1782
This edition first published 2005 by
Pallas Athene (Publishers) Ltd,
Studio 11A, Archway Studios,
25-27 Bickerton Road, London N19 5JT
New edition 2020
© Pallas Athene 2005, 2020
Hardback ISBN 978-1-84368-197-7 Paperback ISBN 978-1-84368-004-8

www.pallasathene.co.uk

@Pallasathenebooks @Pallas_books

@Pallasathenebooks @Pallasathene0

Special thanks to Richard Humphreys, David Blayney,
Richard Morgan, Barbara Fyjis-Walker and Piers Blofeld

Textual Note:

The *Observations on the River Wye, &c*, were first published in 1782
(though they did not actually appear until 1783, owing to a problem with the prints).
This edition reproduced that of the revised fifth edition of 1800, for which the aquatints
were renewed. Spelling has been lightly, and punctuation very lightly, modernized,
and the currently accepted version of place names have been substituted for ease of reference.
All the original images have been reproduced in colour. They were not given captions
by Gilpin, possibly in keeping with his intention of showing only an idea,
not a portrait, of a given site. In this edition the pictures have been placed
as close as possible to the same position in the text, except where noted.
The cover is *On the Wye*, studio of Richard Wilson (1731-1782), courtesy Tate Gallery